DUTCH DESIGN COWBOYS

WORK BY STUDIO KLUIF

BIS PUBLISHERS

BIS Publishers Building Het Sieraad - Postjesweg 1 - 1057 DT Amsterdam - the Netherlands - T +31 (0)20 5150230
bis@bispublishers.com - www.bispublishers.com - **ISBN 978 90 6369 538 5** - Copyright © 2019 Studio Kluif & BIS

INTRO

Brabant's no-nonsense mentality leading to global excellence

"Again prestigious Pentawards for Studio Kluif" and "worldwide excellence in packaging design". Impressive results this year once more for a passionate but down to earth design studio just around the corner here in the South of the Netherlands.

About three years ago I discovered Studio Kluif, being one of the jury members reviewing all kind of creative work coming from agencies based in Brabant. Although this competition is of course completely different (modestly said) from all international competition they face, their work, ranging from brand communication, corporate identities and packaging design, always surprises and stands-out. For me it is often a 'typical Kluif'. So what is this exactly? What makes their work 'typically Kluif' for me?

Is it their roots: the region? Brabant is an economic, social, cultural and ecological strong region. Eindhoven has become a true centre of design with the Dutch Design Week and Design Academy. Historians mention the boosting role of the region and the down to earth mentality of rolling up your sleeves, finding innovative solutions and just make it happen. Characteristics that you recognise immediately meeting the people behind Kluif and when you enter their office. Is it this mentality and their guts and drive to do things differently, not following the crowd?

What struck me every time again is the importance and power of good packaging design: no matter how good the product is within, it wouldn't sell without a design reinforcing what the product or brand stands for. Kluif stands out in understanding

their clients and the brands they work for. Client briefings often contain too many messages and product benefits marketeers want to bring across: it's tough to make choices/kill your darlings. Single minded messaging however is most powerful, and understanding the brand's DNA is crucial. Kluif brings focus and delivers daring, powerful, uncompromising work. Needless to say they use the same method for their work for identities, campaigns and product design.

This book, like the previous ones, proves that unique design can be entertaining and is truly inspiring. Even not knowing all brands, the messages are clear. The designs tell a story and are often based on an insight that we all know and recognise. Few favourites of me are Painkiller: spot-on the way the typeface is used and how the picture illustrates the feeling you have when you need this product badly. Also Uncle Orange, contemporary mugs, a proof of packaging that reinforces a story, the story of loneliness. Clever how it brings young and old together. And last but not least, one of the Pentaward winners: 'Go out!' A series of toys of a Dutch retailer Blokker: where powerful design reinforces the message and insight that best days indeed should always end in dirty clothes.

I wish you fun and a lot of inspiration reading the book. Reading it myself, it makes me proud. Proud of this work created here, just around the corner.

Cheers!

Esther de Vilder
Head global Communications
at Royal Swinkels Family Brewers

Dare to Differentiate

Recently we organised our 8th retail loyalty congress in Amsterdam. We organised this event for over 250 different grocery retailers coming from across the globe.

This years theme was 'dare to differentiate'. It was a call to action to all our clients, grocery retail, to start elevating themselves out of what we call 'the sea of sameness'. Not only grocery retailers, but many other retailers and manufactures or brands have difficulty in figuring out how to stand out in the crowd today.

Price and product are not the differentiation drivers anymore, and while everybody talks about data and digital, it's about finding the right story and continuously rejuvenate this and bring it to life. What's probably most fascinating is that stories and our ability to convey them have always been crucial in the development of mankind in general and still are today.

The challenge is that many stories already have been told and that digital transformation has created an abundance of messages and different actors to tell them.

But also marketing organisations have changed who are still responsible for this story, but have cut down their departments into small pieces, ranging from product to client to activation to digital departments with nobody anymore overseeing the overall story.

These changes demand a different approach. It's about being fully aware that new generations want to be addressed completely differently. It's about taking needs and desires as a starting point, which needs to exceed the limits of your product or service, addressing them as citizens not consumers.

It's about disrupting and daring design if you want to create any stopping power in this new world where an average individual is being bombarded with thousands of messages on a daily basis. It's about reaching to the heart of your consumer by being more honest, open and emotional.

On our last congress we had Jimmy Nelson, a world known photographer of native tribes, who started with a personal story on how he was abused as a child at boarding school and that that specific experience drove him to the most remote places in the world, where he, to his own surprise, found back his trust and affection for other people. It's a good example about how a much deeper and personal

story tells the relevance of his photography and the people he portrayed.

But also the agency world need to start taking back their position on helping retailers, brands and manufacturers to bring these scattered marketing departments together in one strong compelling story, through great content, design, communication and experience.

I met Paul over 3 years ago in a panel and I vividly remember he presented his Jheronimus Bosch dinnerware items. An initiative in which he combined his entrepreneurial drive and passion for design.

Although we had our own internal creative agency, I dared to look outside and invited Kluif to see if we, Brandloyalty a global provider of stamp based loyalty campaigns for grocery retailers, could do some collaboration. He first presented to me the classic tea cups with the grand mothers stories on the box. Brilliant how you could take a product category like tea cups, through emotional content, design and authentic story telling, out of the sea of sameness of dinnerware were many brands and manufacturers have found their grave in the recent decades.

Kluif helped us in bringing to life our business solutions through the brilliant concept of gift boxes. These 24 different boxes unfolded a story from retailer insights into the consumers insight into the the emotional sides of our brands and finally the loyalty and activation solutions we provide through unique storytelling and design.

A journey for Kluif who dared to dig deep into the mechanics of our business, the characteristics of our clients, the many different brands we work for ranging from Disney, Star Wars to Jamie Oliver, Zwilling and Villeroy and Boch.

The result is a complete different way in which we try to connect our solutions to our clients. Taking their challenge as a starting point and general unfolding a story towards what our solutions can do for them. A more daring, but differentiating approach which at least helped us to differentiate versus the competition, slightly elevating Brandloyalty out of our own 'sea off sameness'.

Regards,

Marco van Bilsen
Global Marketing Director
Brandloyalty

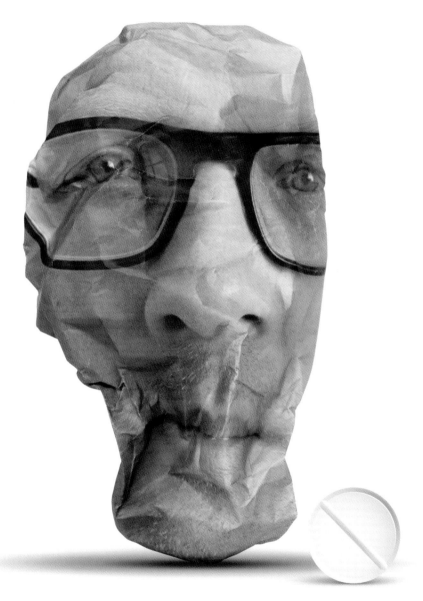

Fed up with board meetings about strategies, mission and vision? At Studio Kluif we welcome you with a refreshing remedy. After taking one of these painkillers to get rid of the first sores we'd like to invite you on a creative journey that makes you forget all the things you already know. So kill the pain and let us bring your ideas come alive. With this out of the box piece of self promotion Kluif likes to invite existing and future clients to get out of their boardrooms and into Kluif's office. So if it feels as if your head is being crushed by all the stress it's time for a Kluif painkiller and give them a call. A self promotion as extraordinary and surprising as their work, guaranteed to put a smile on your face.

08-11 client studio kluif, 's-hertogenbosch **project** self promotion painkiller packaging range **year** 2019 **award** nomination pentawards 2019

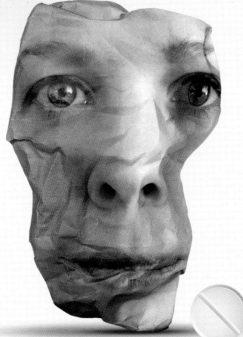

Paink._ller®

Can't get your head around things anymore?
Give us a call for some relief and good ideas.

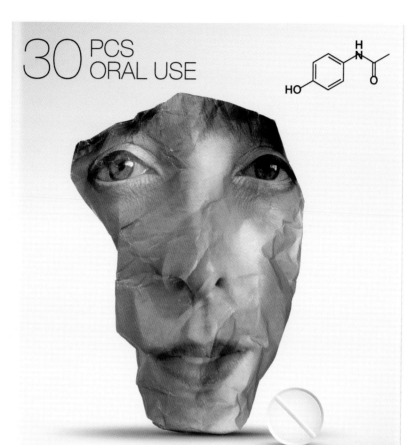

Paink._ller®

Can't get your head around things anymore?
Give us a call for some relief and good ideas.

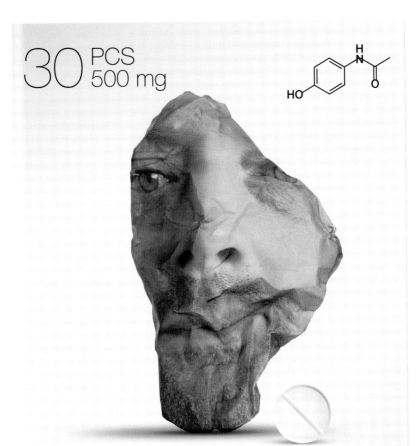

30 PCS 500 mg

Paink._ller®

Can't get your head around things anymore?
Give us a call for some relief and good ideas.

The Fatboy collection consists of a wide range of indoor and outdoor design items. Available in a broad colour palette and many materials. From lamps, ottomans and carpets to side tables, parasols and a two-person hammock. Developed with one goal: escaping the daily routine with a big smile. In this booklet you can meet the entire Fatboy product portfolio.

12-19 client fatboy, 's-hertogenbosch **project** product brochure 'hi! how are you?', in collaboration with fatboy design **year** 2018

fatboy

Fatboy's collection consists of a wide range of indoor and outdoor design items. Available in a broad colour palette and many materials. From lamps, poufs and carpets to side tables, parasols and a two-person hammock. Developed with one goal: escaping the daily routine with a big smile.

Let me give you an introduction...

SAY HI TO THE ORIGINAL

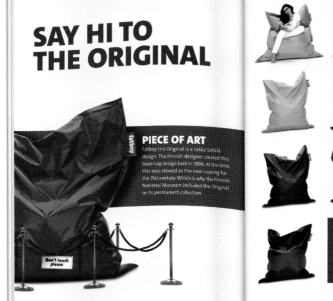

PIECE OF ART

Fatboy the Original is a Jukka Setälä design. The Finnish designer created this bean bag design back in 1998. At the time, this was viewed as the new seating for the 21st century. Which is why the Finnish National Museum included the Original in its permanent collection.

Don't touch please

THE HIGHEST ORIGINAL EVER TO BE FOUND WAS ON THAT OTHER ORIGINAL, THE MOUNT EVEREST. NOBODY KNOWS HOW, BUT THE WHY SHOULD BE CLEAR.

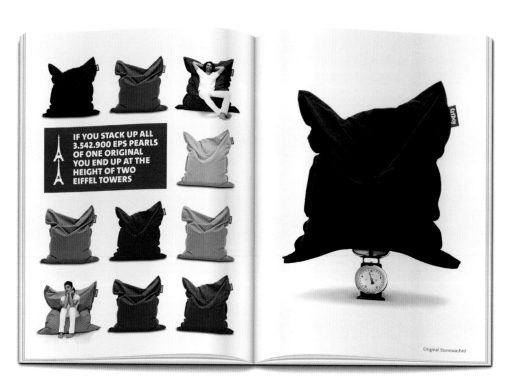

IF YOU STACK UP ALL 3.542.900 EPS PEARLS OF ONE ORIGINAL YOU END UP AT THE HEIGHT OF TWO EIFFEL TOWERS

Original Stonewashed

THE ORIGINAL BEANBAG FAMILY TREE

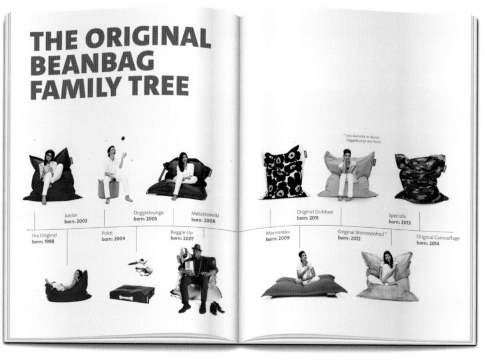

* also available as Junior, Doggielounge and Point

the Original
born: 1998

Point
born: 2004

Junior
born: 2003

Doggielounge
born: 2005

Buggle-Up
born: 2007

Métahlowski
born: 2008

Marimekko
born: 2009

Original Outdoor
born: 2011

Original Stonewashed *
born: 2012

Specials
born: 2013

Original Camouflage
born: 2014

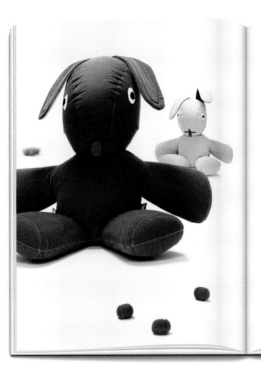

CO9 WANTS A HUG

Meet this iconic stuffed bunny. Phonetic for rabbit (konijn) in Dutch.

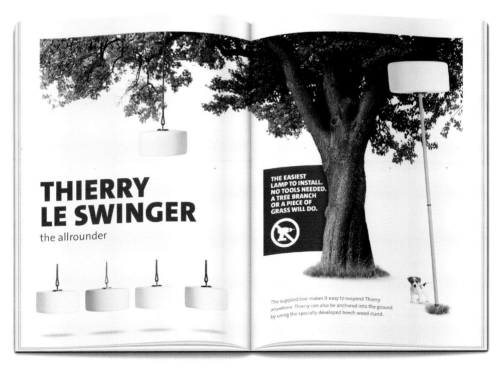

THIERRY LE SWINGER

the allrounder

THE EASIEST LAMP TO INSTALL. NO TOOLS NEEDED. A TREE BRANCH OR A PIECE OF GRASS WILL DO.

The supplied line makes it easy to suspend Thierry anywhere. Thierry can also be anchored into the ground by using the specially developed beech wood stand.

Don't let a Edison the Petit go bare-naked! Fatboy has the perfect cappie for every setting, situation and mood.

SHAKE HANDS WITH COOPER CAPPIE

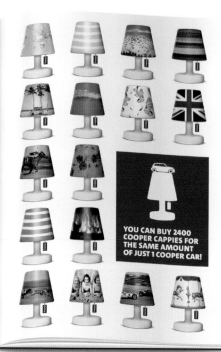

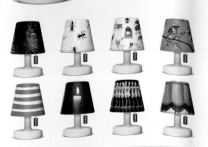

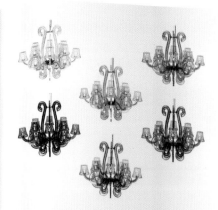

A SHOUT OUT TO ROCKCOCO!

Coloured design chandelier

The Rockoco transparant is also perfect for outdoor use.

WINK TO TRANSLOETJE

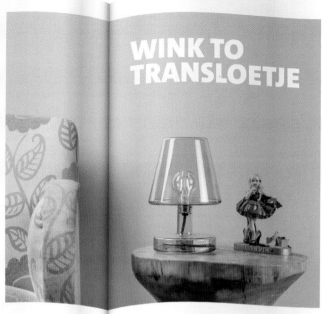

A NON FLYING CARPET

Inspired by authentic Kelim and Persian carpets, reinvented by Fatboy. Featuring unexpected details and beautifully faded patterns the Non-Flying Carpets creates instant atmosphere with a typical Fatboy twist.

THE SIZE OF A NON FLYING CARPET IS SHEER ENDLESS. WHY NOT TRY A WHOLE SOCCER FIELD!

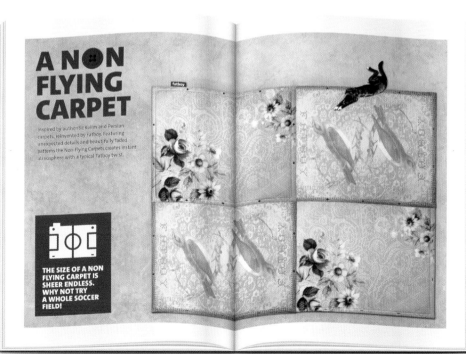

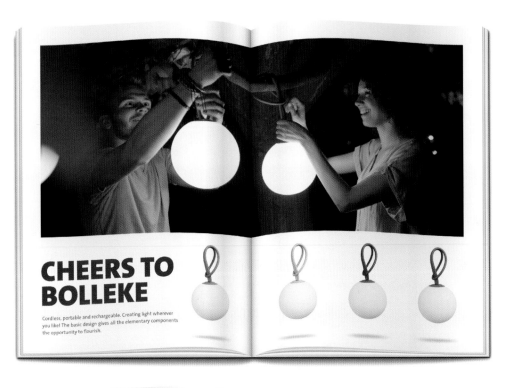

CHEERS TO BOLLEKE

Cordless, portable and rechargeable. Creating light wherever you like! The basic design gives all the elementary components the opportunity to flourish.

BYE BYE, IT WAS NICE MEETING YOU!

LET'S MEET AGAIN?

phone `073 6230707`

or fatboy.com

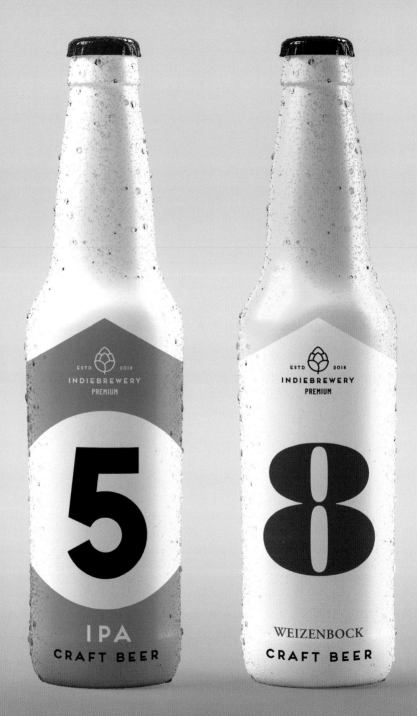

Kluif designed an iconic beer packaging range for Indiebrewery. It uses iconic race graphics in a clear and modern way. The numbers refer to the percentage of alcohol. Time for a little pit stop.

20-23 client indiebrewery, antwerp **project** beer packaging range 'pit stop' **year** 2019

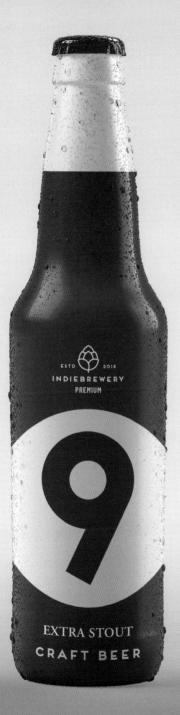
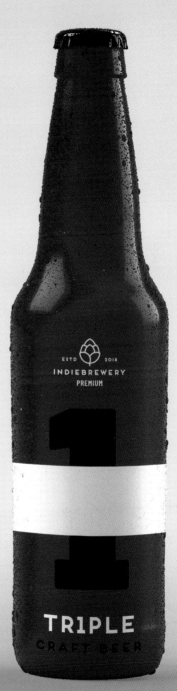

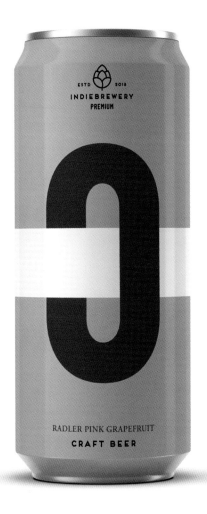

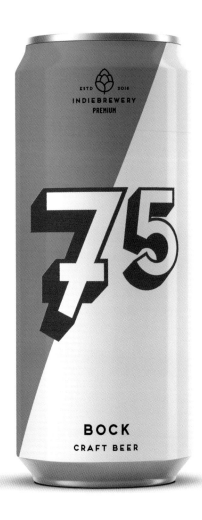

TR1PLE

1

ESTD 2018
INDIEBREWERY
PREMIUM

CRAFT BEER

ESTD 2018
INDIEBREWERY
PREMIUM

5

IPA
CRAFT BEER

ESTD 2018
INDIEBREWERY
PREMIUM

9

EXTRA STOUT
CRAFT BEER

WEIZENBOCK

ESTD 2018
INDIEBREWERY
PREMIUM

8

CRAFT BEER

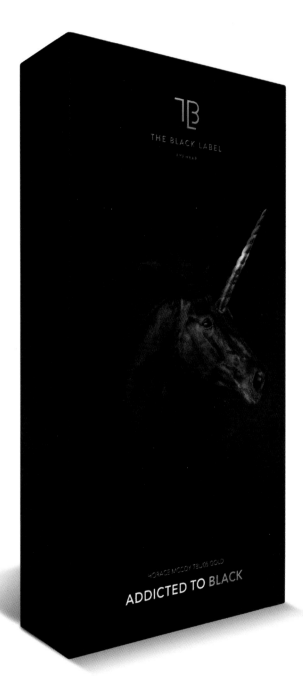

The Black Label is a highly fashionable eyewear brand that is specialized in state of the art titanium frames. They are known for there dark appearance and the always recurring golden details. For The Black Label frames packaging range we made an intriguing series of images that emphasize the uniqueness of the frames, almost as if they were pulled out of liquid gold.

24-27 client the black label, rosmalen **project** glasses gift box collection **year** 2018

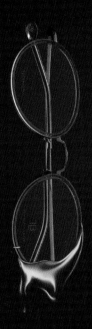

TB

THE BLACK LABEL

EYEWEAR

TRUMAN CAPOTE TBL/02 BROWN

ADDICTED TO BLACK

THE BLACK LABEL

EYEWEAR

REDMOND O'HANLON TBL/06 MATTE BLACK

ADDICTED TO BLACK

THE BLACK LABEL

EYEWEAR

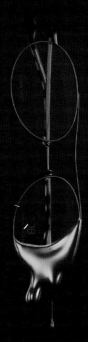

ERNEST HEMINGWAY TBL/01 MATTE GOLD

ADDICTED TO BLACK

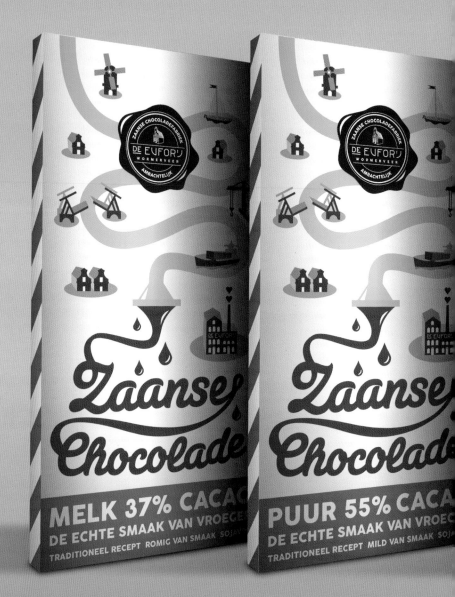

Euforij is an independent Dutch chocolate factory amidst the world's largest cocoa processors. One of the main questions of Euforij was to emphasize on the fact that they produce their chocolate the old fashioned way. The real taste of the past, traditionally made without 'nasty' additives, produced in the area where it all began. Also, the packaging should stand out in grocery stores amidst a wide range of brands with mostly photographic designs. Studio Kluif chose to combine all these elements in a graphical illustration which is a representation of the Euforij area. Complete with a windmill, a tow bridge and the actual Euforij factory which is located alongside the river 'Zaan' popularly called the 'chocolate river'.

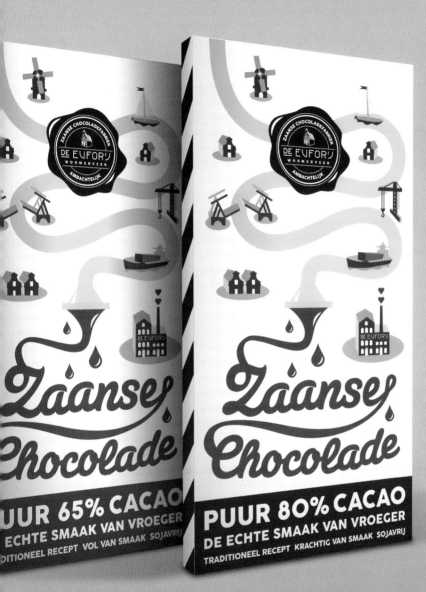

Zaanse Chocolade

PUUR 65% CACAO
ECHTE SMAAK VAN VROEGER
DITIONEEL RECEPT VOL VAN SMAAK SOJAVRIJ

Zaanse Chocolade

PUUR 80% CACAO
DE ECHTE SMAAK VAN VROEGER
TRADITIONEEL RECEPT KRACHTIG VAN SMAAK SOJAVRIJ

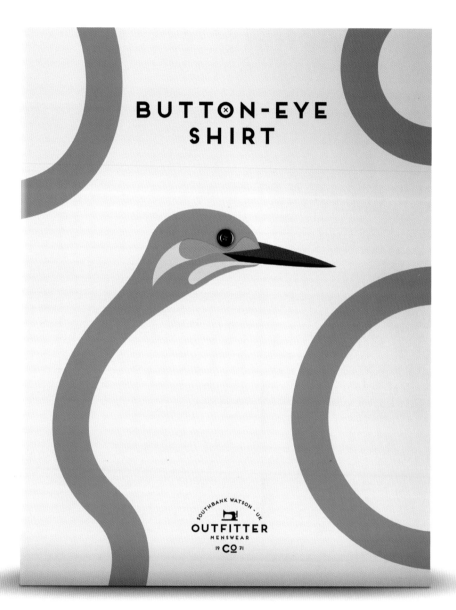

BUTTON-EYE SHIRT

OUTFITTER
MENSWEAR

Studio Kluif designed a menswear shirt collection for underground label Southbank Watson Outfitter UK. The limited-edition shirts are handmade. What makes the shirts unique is the use of the iconic button-eye idea in combination with the illustration. Kluif translated this idea for the button-eye gift box collection. On the gift box, the iconic black button with red yarn plays an unexpected important role resulting in an 'eye-conic' design.

30-35 client southbank watson outfitter uk, liverpool **project** button-eye shirt packaging **year** 2019 **awards** gold pentawards 2019, nomination people's choice award 2019

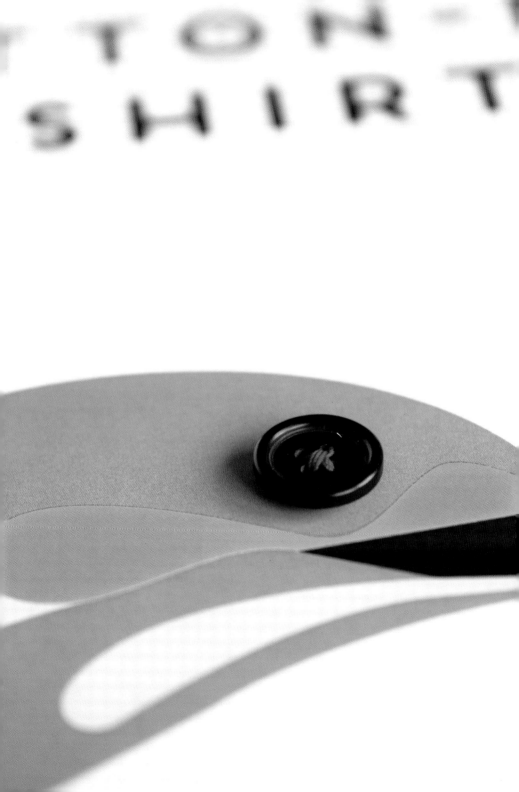

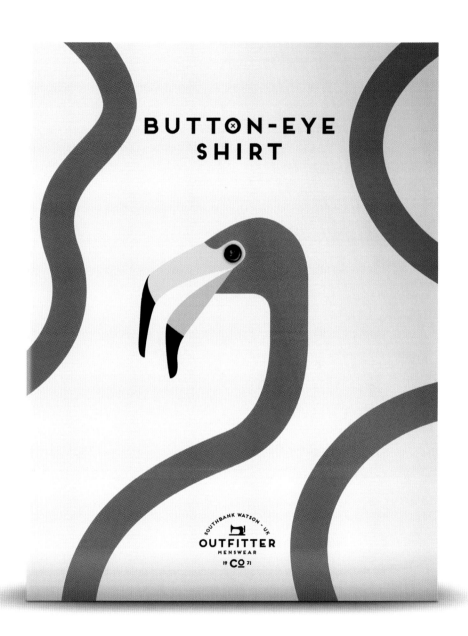

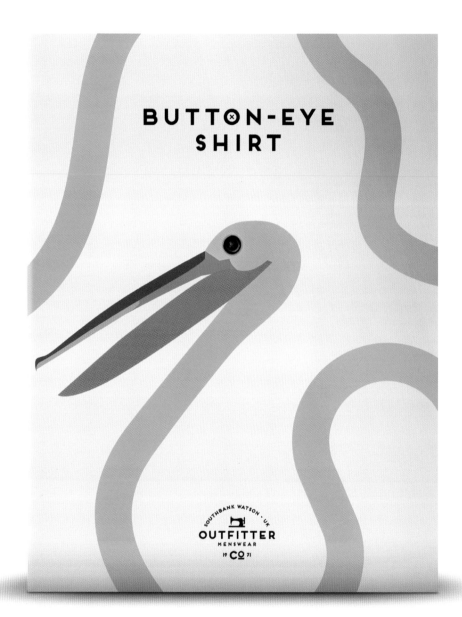

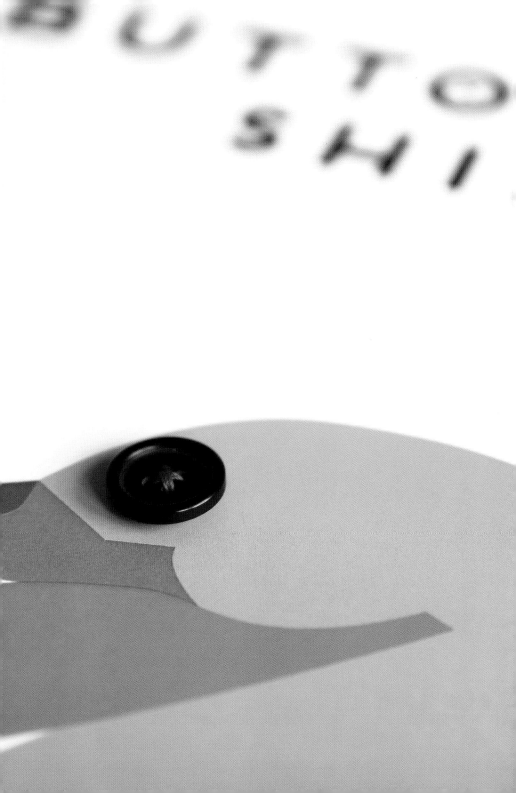

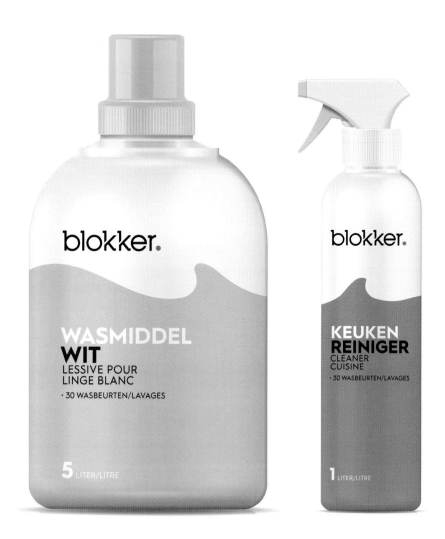

Blokker, founded in 1896, is one of the Netherlands' most famous retailers for household goods and home accessories. With more than 500 stores, Blokker is a trusted name in the shopping streets of the Netherlands. In recent years, Blokker has considerably modernized its formula. This results in a whole new look in the stores and a Blokker private label product range. Since 2017 Studio Kluif works on various packaging ranges such as Christmas decorations, party products, travel accessories, cleaning products and toys. For the Blokker private label cleaning and washing products, Studio Kluif has developed the packaging design. A wave-shaped form, different on each product, refers to the water that is used for practically every cleaning job.

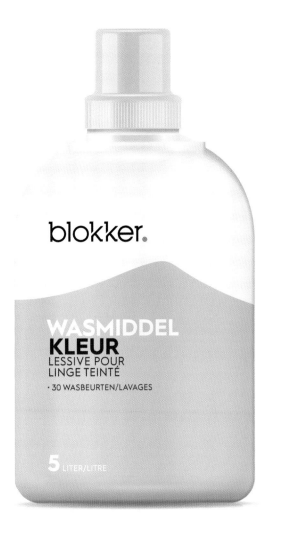

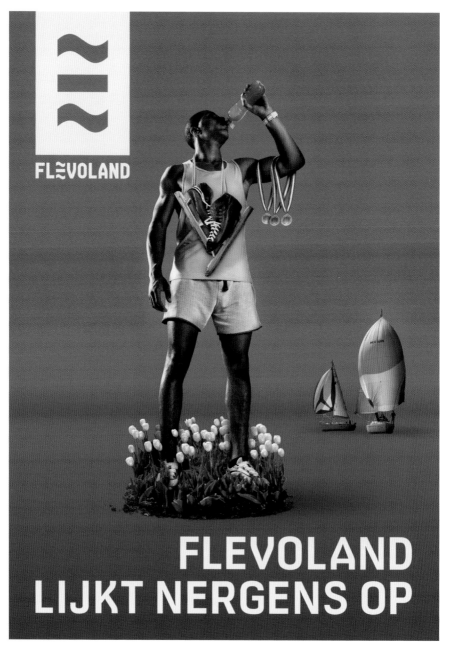

FLEVOLAND
LIJKT NERGENS OP

Visit Flevoland is the destination marketing organization for the holiday & leisure sector in Flevoland. This organization aims to make an attractive destination together with entrepreneurs and other organizations from Flevoland in this sector. Studio Kluif is responsible for all the communication of Flevoland. To boost the launch of the new visual identity of Flevoland, Studio Kluif has developed the campaign 'Flevoland lijkt nergens op' ('Flevoland looks like nothing'). This campaign aims to introduce the new brand nationwide. For this introduction campaign, powerful and distinctive images have been put together for the most important tourist themes: culture, nature, recreation and sport.

38-41 client visit flevoland, lelystad **project** mupi campaign 'flevoland looks like nothing' **year** 2018

FL≋VOLAND

FLEVOLAND
LIJKT NERGENS OP

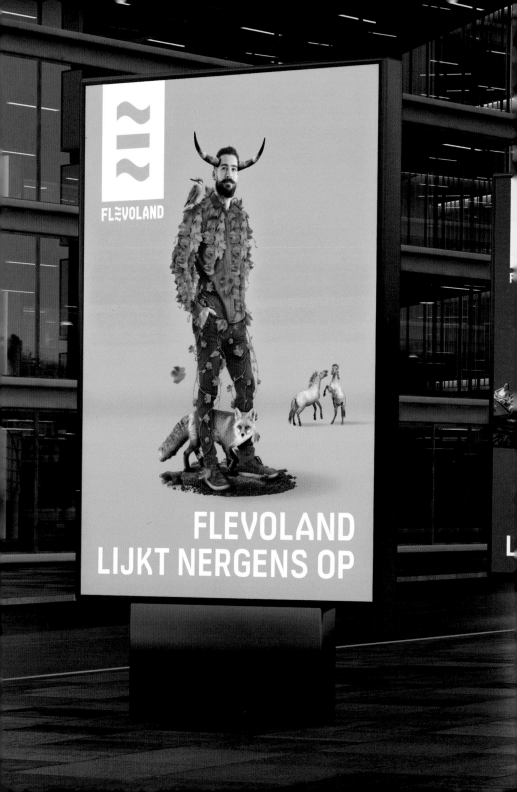

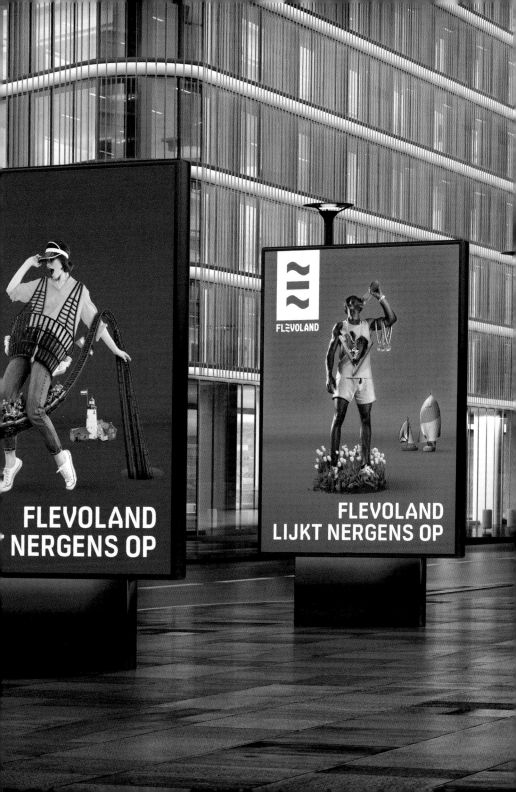

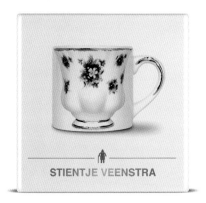

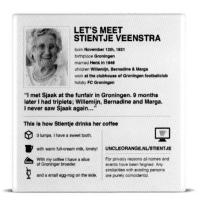

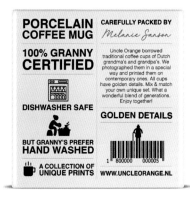

UNCLE ORANGE

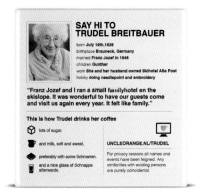

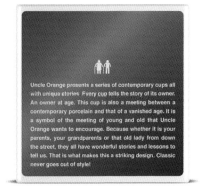

Uncle Orange and Pols Potten bring a series of unique contemporary mugs with unique stories. Every mug tells the story of its owner. An elderly owner. Uncle Orange serves an important social theme, the fight against loneliness among the elderly. We hope this product encourages the meeting between young and old.

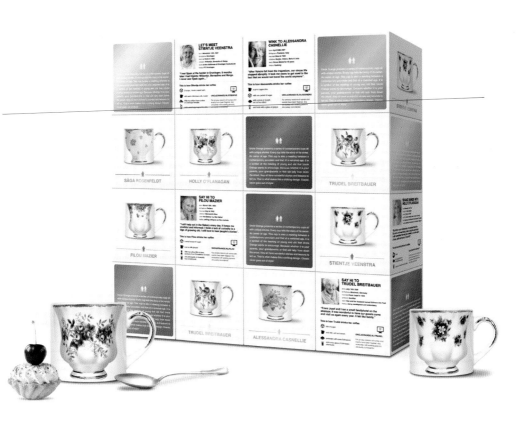

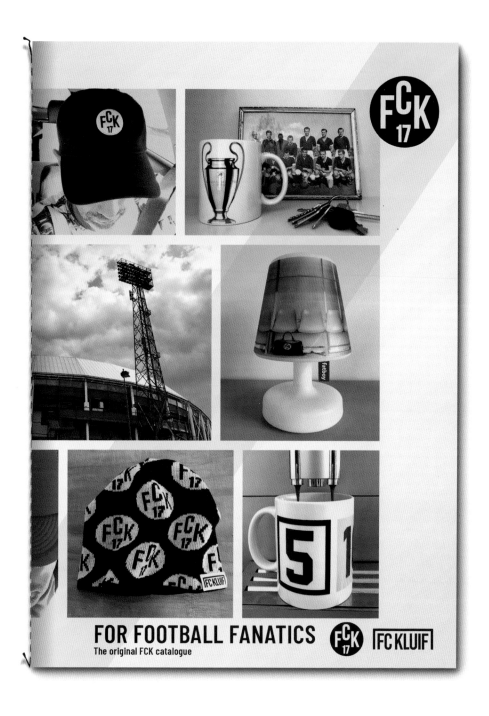

FOR FOOTBALL FANATICS
The original FCK catalogue

FCK is a stylish Dutch men's lifestyle brand with a focus on football. Each FCK product tells its own story. Iconic football players and iconic moments from the rich history of football inspire us. FCK is a brand new initiative from Studio Kluif. Enjoy! That's our goal!

44-49 client fc kluif, 's-hertogenbosch **project** fck catalogue **year** 2018 **awards** silver pentawards 2018, nomination bonk 2018

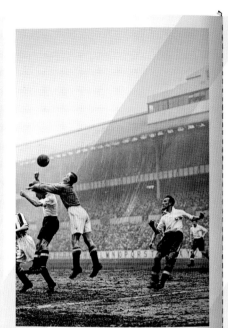

With pride we present the official
FCK catalogue.
Made by football fanatics,
for football fanatics.
FCK is a dutch design cult brand
with a wink to football.
Each product has it's own story.
Iconic football players and iconic
moments from the rich history of
football inspire us.
FCK products are designed with
great care.

So, enjoy! That's our goal!

FCK Poster Collection

(consumers | Maracana)

Size 70 x 50 cm **Paper** 200 grs. icewhite Popyrus FSC certified **Limited edition** 200

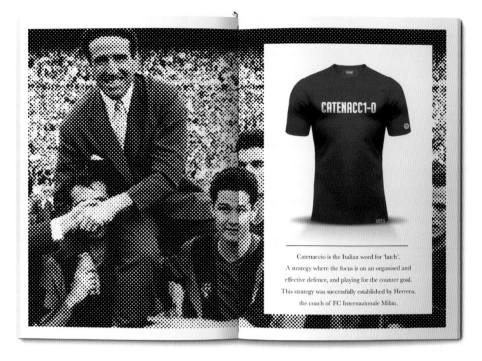

CATENACC1-0

Catenaccio is the Italian word for 'latch'.
A strategy where the focus is on an organised and
effective defence, and playing for the counter goal.
This strategy was successfully established by Herrera,
the coach of FC Internazionale Milan.

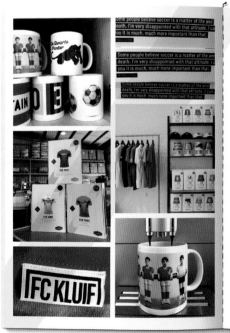

Some people believe soccer is a matter of life and death. I'm very disappointed with that attitude. I can you it is much, much more important than that.

Some people believe soccer is a matter of life and death. I'm very disappointed with that attitude. I can you it is much, much more important than that.

Some people believe soccer is a matter of life and death. I'm very disappointed with that attitude. I can you it is much, much more important than that.

FC KLUIF

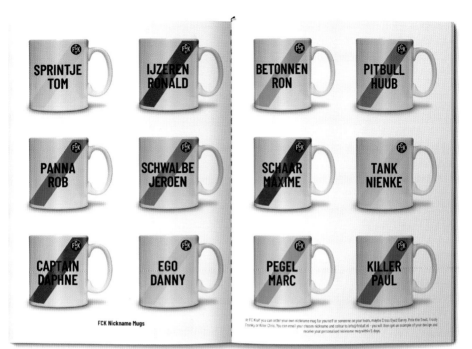

FCK Nickname Mugs

At FC Kluif you can order your own nickname mug for yourself or someone on your team, maybe Cross Eyed Danny, Pete the Snail, Frosty Franky or Killer Chris. You can email your chosen nickname and colour to info@fckluif.nl - you will then get an example of your design and receive your personalised nickname mug within 5 days.

FCK Lamps

In co-operation with Fatboy, FC Kluif has designed a lamp collection. Introducing the mobile table lamp you've always wanted. Functional on your desk and handy next to your bed, this small white table lamp with an FCK Cappie brings the right amount of light into the darkness - and football into your home. It is multifunctional, attractive and its rechargeable battery lasts 8 to 24 hours. The lamp has three different light settings, is wireless, and can be used both in and outdoors. Is football the light of your life? If so, this lamp is a must-have. Dimensions 16 x 25 cm.

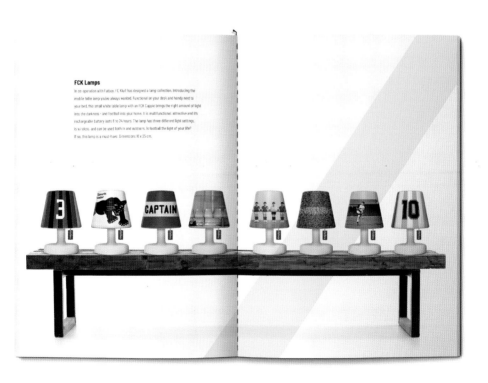

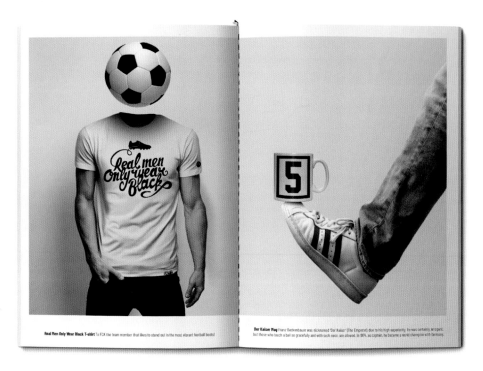

Real Men Only Wear Black T-shirt To FCK the team member that likes to stand out in the most vibrant football boots!

Der Kaiser Mug Franz Beckenbauer was nicknamed 'Der Kaiser' (The Emperor) due to his high superiority. He was certainly arrogant, but those who touch a ball so gracefully and with such ease, are allowed. In 1974, as captain, he became a world champion with Germany.

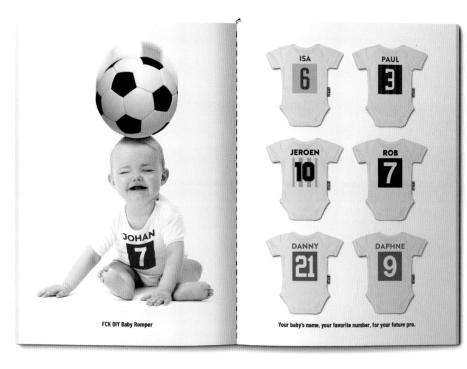

FCK DIY Baby Romper

Your baby's name, your favorite number, for your future pro.

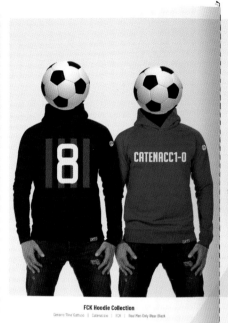

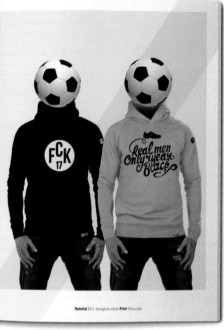

FCK Hoodie Collection

Gennaro Rino Gattuso | Catenaccio | FCK | Real Men Only Wear Black

Material 85% biological cotton **Print** Silkscreen

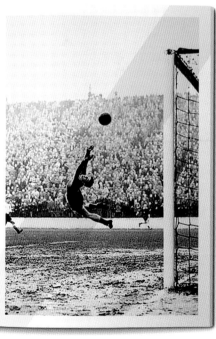

For the entire FCK collection visit fckluif.nl

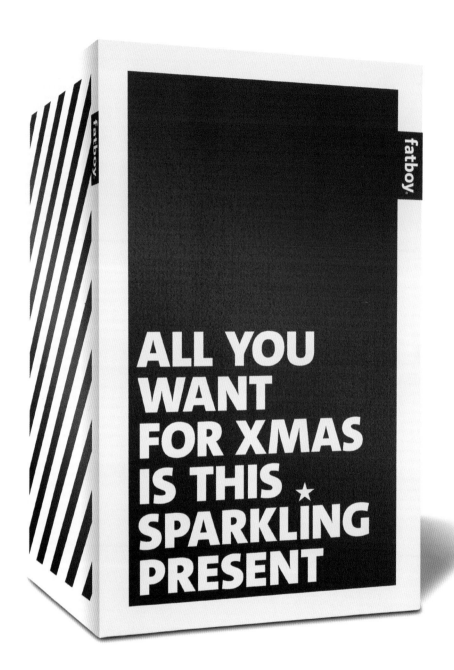

ALL YOU
WANT
FOR XMAS
IS THIS ★
SPARKLING
PRESENT

How to make an existing product special? The answer is as brilliant as it is simple. By pulling a sleeve over the Edison the Petit box the product got an instant Xmas present feel. In shops, this also worked nicely as display material.

50-51 client fatboy, 's-hertogenbosch **project** special edition christmas packaging 'edison the petit' **year** 2018

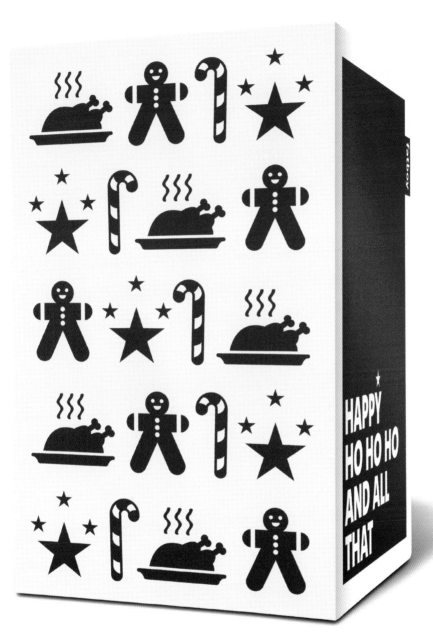

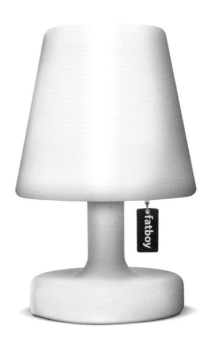

With the Fatboy Xmas treetopper you can turn your Edison Petit table lamp into a real christmas tree.
No more pine needles!

52-55 client fatboy, 's-hertogenbosch **project** edison the petit christmas treetopper collection and pos object **year** 2018

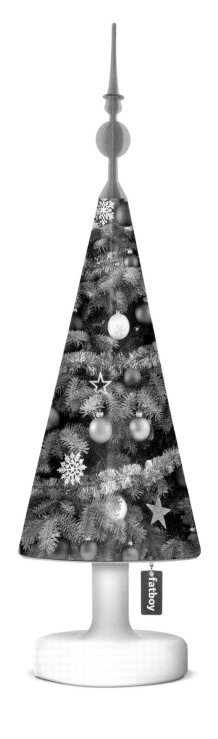

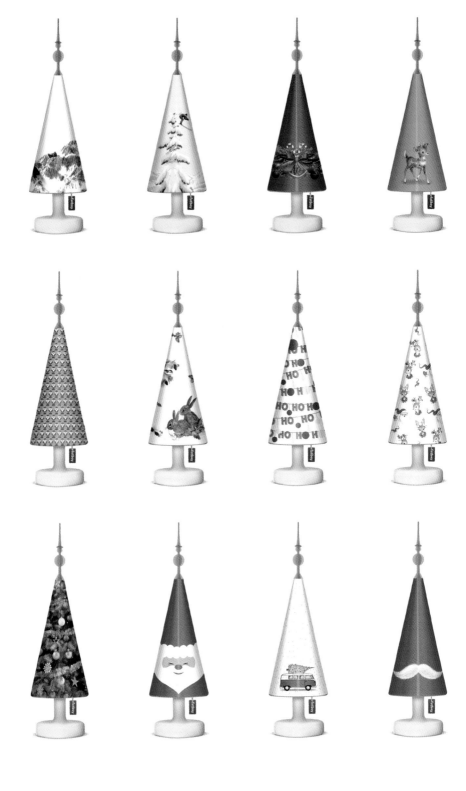

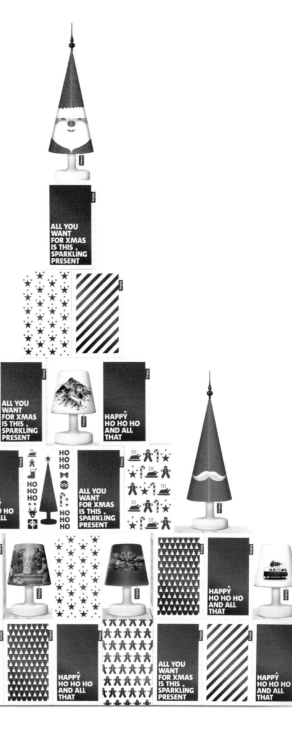

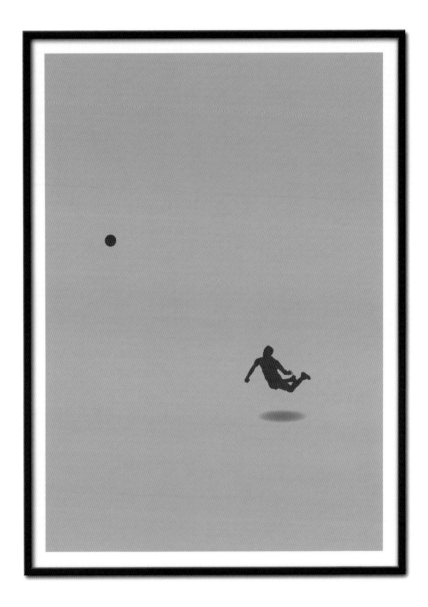

Iconic FCK posters picturing iconic historical football moments. Only for real football fanatics!

56-57 client fc kluif, ´s-hertogenbosch **project** fck posters **year** 2018 **awards** silver pentawards 2018, nomination bonk 2018

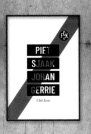

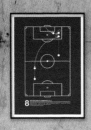

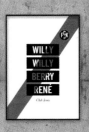

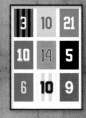

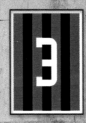

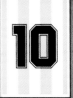

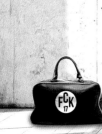

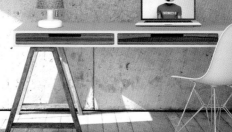

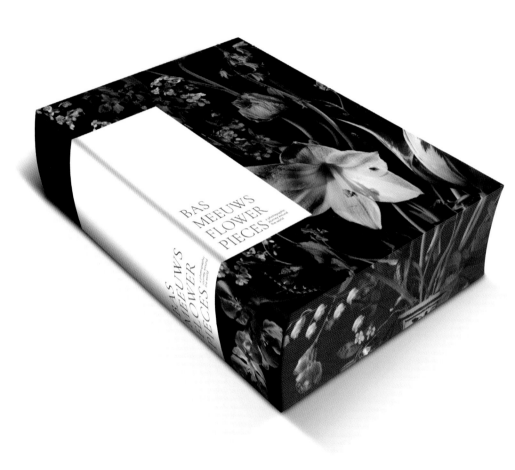

Oil on panels makes way for digital photography. Bas Meeuws is a young photographer who is injecting the traditional Dutch genre of the flower piece with new élan. He composes his work the way the old masters did, flower by flower in luxury and splendour. The result is a layered photography that transcends time. Beauty and nature, technique and history, structure and art. Meeuws weaves all these aspects together in splendid pieces, beautifully composed and fashioned with love. While he maintains the richness and splendour of the past, digital photography allows him to get so close to his flowers that they immediately touch us. Studio Kluif has designed and developed this unique coffee table book by Bas Meeuws. The book of no less than 352 pages covers the entire oeuvre of Bas Meeuws, supplemented with many special commissions for the Rijksmuseum Muiderslot and Emma, among others. What makes the book really special is the full-colour press-to-cut.

HOLLAND

Flower pieces in the Golden Age
荷蘭 黃金時代的花卉作品

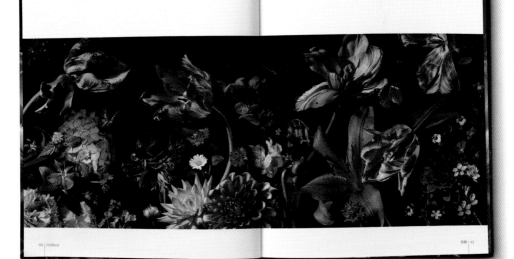

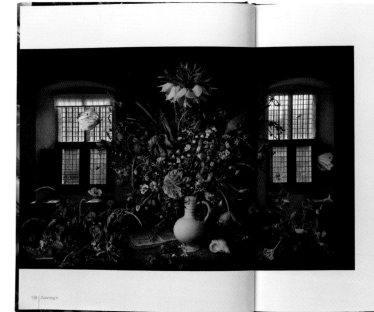

The Sweet Spring
in Wintertime
Celebrating the Muses

The overwhelming floral beauty in *The Sweet Spring in Wintertime* offers a glimpse of the botanical wealth in the gardens of Amsterdam Castle Muiderslot. Bas Meeuws was commissioned by its curators to create this impressive still life to celebrate the twentieth anniversary of the Muses, the volunteers who—as long in the gardens are in bloom—decorate the furnished rooms of the castle with seventeenth-century flower arrangements.

The Sweet Spring in Wintertime ode in Dutch *De foie ten la wintright* was an ode to Maria Tesselschade Roemersdr Visscher (1594–1649) and the art of flower arranging in the Golden Age. The history of this art in the Netherlands can be traced back to the seventeenth century, the time of Vollenar, poets, playwright and Muiderstein nobles PC Hooft, and Tesselschade Muiderslot's original Muse. During her annual rites with the Hooft family Maria Tesselschade would make beautiful floral wreaths and festoons for the great hall of the castle.

21st century florilegium
Bas Meeuws moved into the North Tower (Noodertoren) for a whole year and documented four seasons of everything that grows and blooms in and around the castle and its historic gardens and orchard. The flowers, fruit, insects and other subjects were photographed from all angles in the same artificial light with utmost surgical precision. Every stage and detail, from opening to wilting, was recorded.

Meeuws used these images to make his own photographic *florilegium* (flower book) and, just as the Old Masters in the Golden Age based their bouquets on a composition of

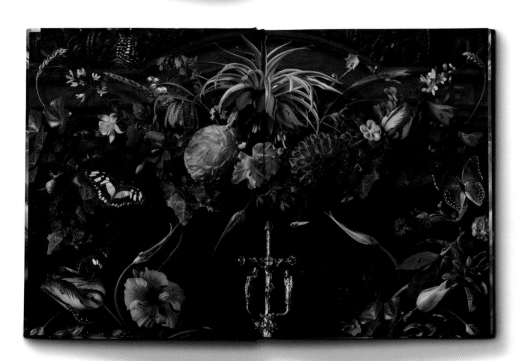

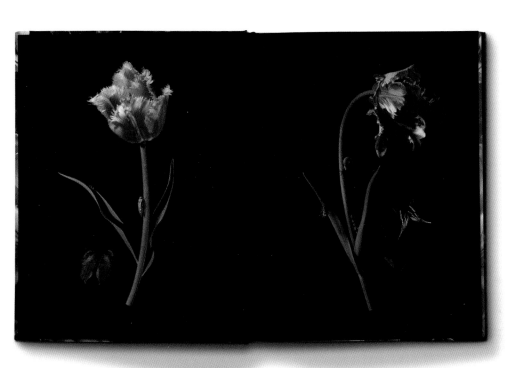

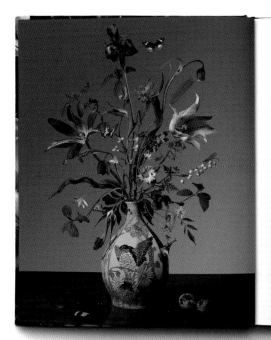

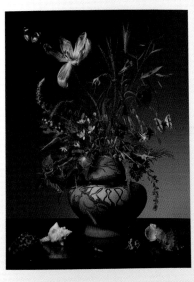

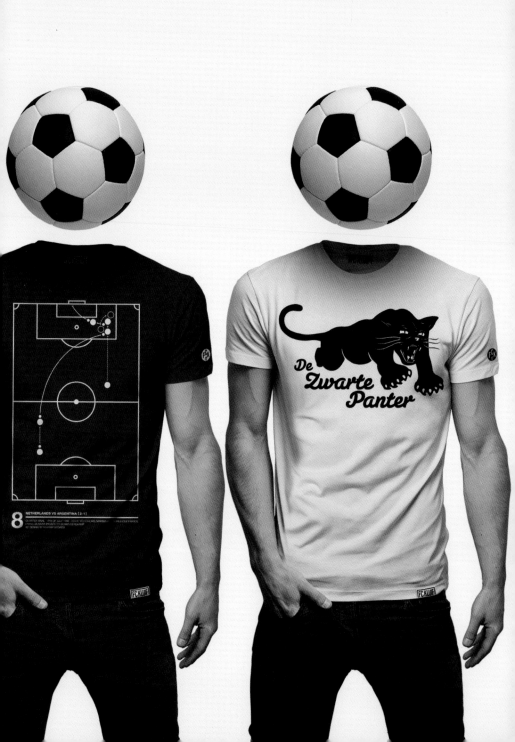

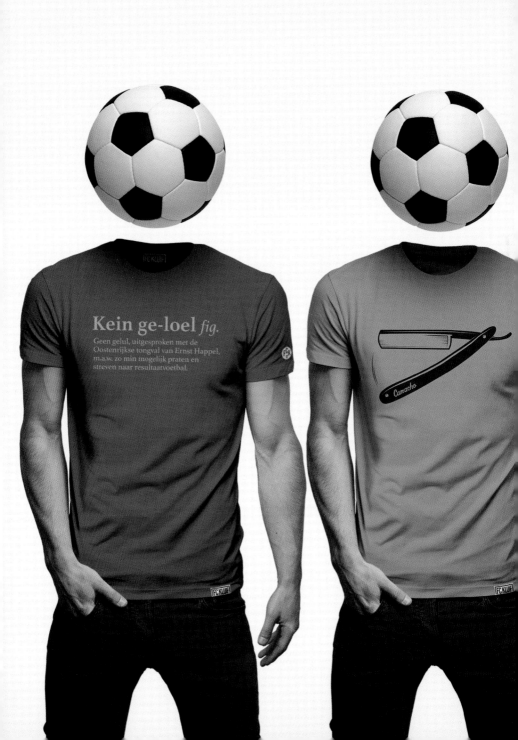

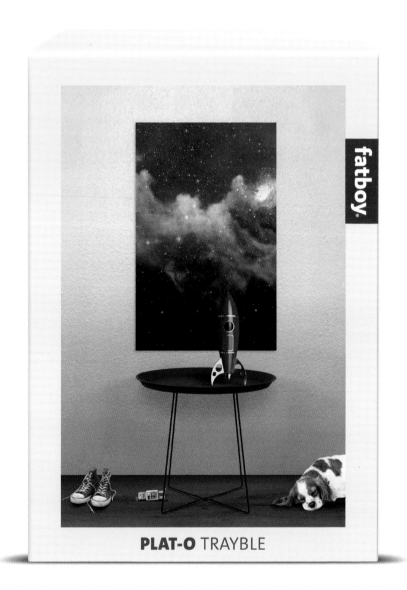

PLAT-O TRAYBLE

Studio Kluif and Dutch Design brand Fatboy share a long history. In this case Studio Kluif designed the packaging range for the new Fatboy side table collection called the Plat-o. The tables are produced in various colours. For each coloured table Kluif came up with a strong image. The tables are photographed in different interior settings. But this time we came up with interior photography with a twist. Background and foreground interact surprisingly!

62-63 client fc kluif, 's-hertogenbosch **project** fck t-shirt collection **year** 2018 **awards** silver pentawards 2018, nomination bonk 2018
64-67 client fatboy, 's-hertogenbosch **project** plat-o trayble collection packaging range, in collaboration with fatboy design **year** 2018
award bronze pentawards 2019

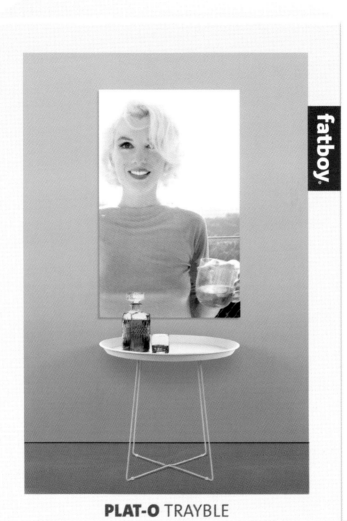

PLAT-O TRAYBLE

PLAT-O TRAYBLE

PLAT-O TRAYBLE

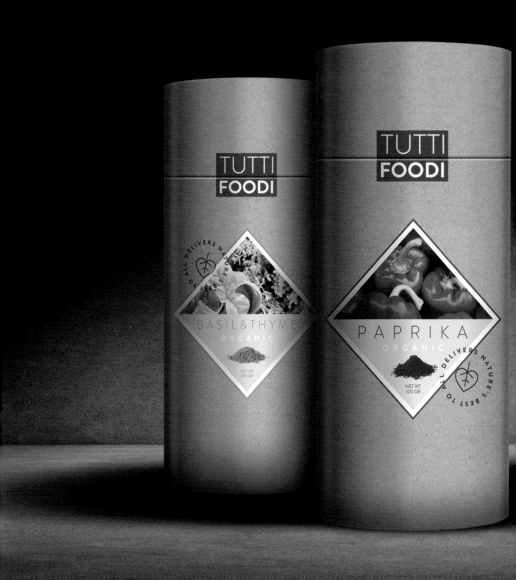

Studio Kluif designed the packaging range for these unique taste creators and ready to use products.
With TuttiFoodi it is possible to conveniently add fresh taste to dishes or to create completely new products.
A culinary revolution in cooking! TuttiFoodi is committed to a sustainable and fair food system. TuttiFoodi also
ensures a low footprint and works on fair income distribution in the food chain as a whole. As this product has
a highly sustainable and fair character so does the packaging. Made of cardboard the tubes can be used several
times since refills are available. Tasteful design for a tasteful product.

68-69 client tuttifoodi, rossum **project** tuttifoodi packaging range **year** 2018

TUTTI
FOODI

TUTTI
FOODI

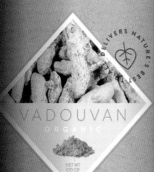

VADOUVAN
ORGANIC

NET WT
100 GR

DELIVERS NATURE'S BEST

UMAMI
ORGANIC

NET WT
100 GR

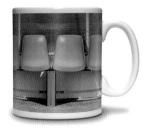

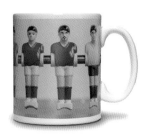

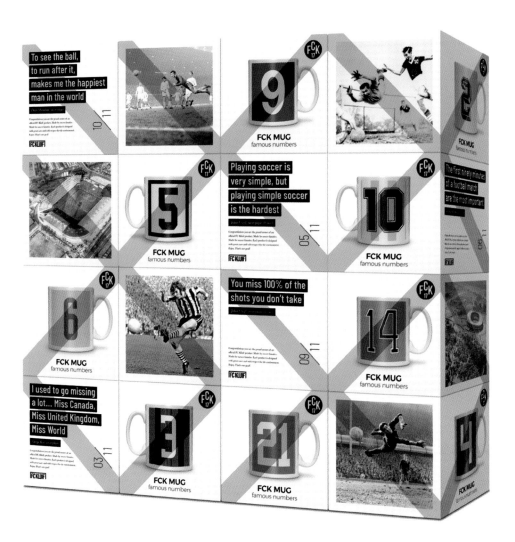

FCK is a stylish Dutch men's lifestyle brand with a focus on football. FCK is Kluif's own initiative. Studio Kluif designed an FCK mug collection. Because let's be honest, a football fanatic's cup of coffee simply belongs in an FCK mug!

Brandloyalty is one of the largest players in the world in the field of loyalty promotions. Every year Brandloyalty organizes a two-day conference where the most important people of the largest fast moving consumer goods companies are kept informed of the latest trends in loyalty programs.

In 2018, the grandeur of the conference was made very personal by surprising the visitors in their hotel room with a tailor-made proposal for a loyalty program. With an ever-changing offer of three different boxes, in which step by step a loyalty concept is revealed, the recipient is challenged and seduced.

72-73 client brandloyalty, ´s-hertogenbosch **project** program box range **year** 2018 **awards** nomination bonk 2018

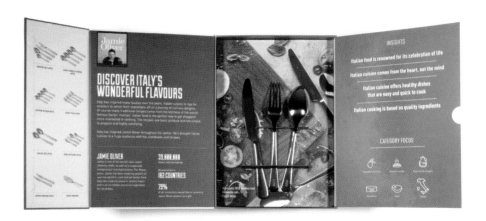

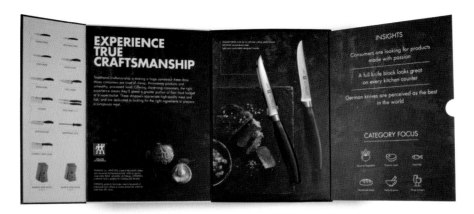

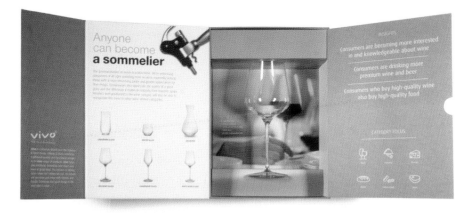

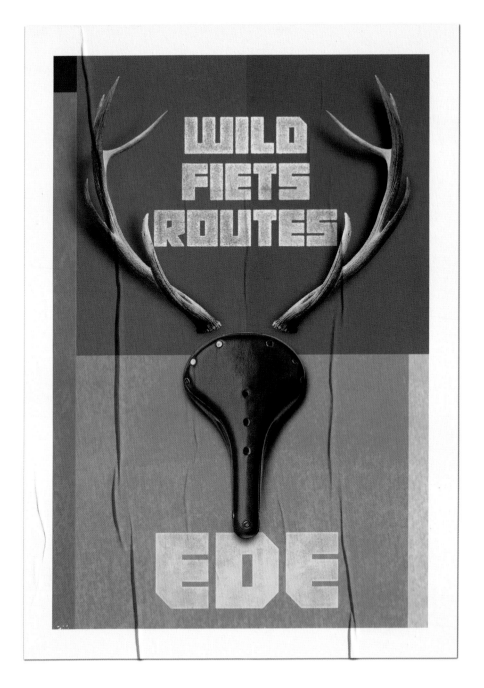

Ede is a municipality in the Dutch province of Gelderland, to be found on the western flank of the Veluwe and the southern Gelderse Vallei. The municipality of Ede covers around 32,000 hectares, making it the 9th largest municipality in the Netherlands. Kluif designed a visual identity for the touristic sector of Ede with a natural feel. In addition to the general identity of Ede Marketing, Kluif made strong visuals for the top destinations and events that can be visited in the area.

HISTORISCHE HEIDE

EDE

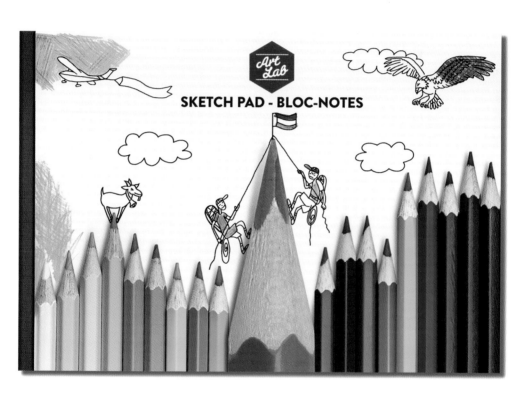

ArtLab is a series of hobby products with children as the main target group. The brief was to create a packaging range that would stimulate the imagination and would invite to create. Most competitors use images of highly skilled illustrators on their products. At Kluif we believe that this works as a high threshold for little creatives so we chose to do it differently. The illustrations that decorate the packaging interact with the products in an imaginative way. So a row of pencils can become a mountain range on which climbers have their peak performance or in the other case you find yourself in a Tour de France stage. The illustrations where made in a way that children can relate to them and catch their attention. They open up a world of creative possibilities and imagination.

76-77 client artlab, rotterdam **project** packaging range hobby products **year** 2018

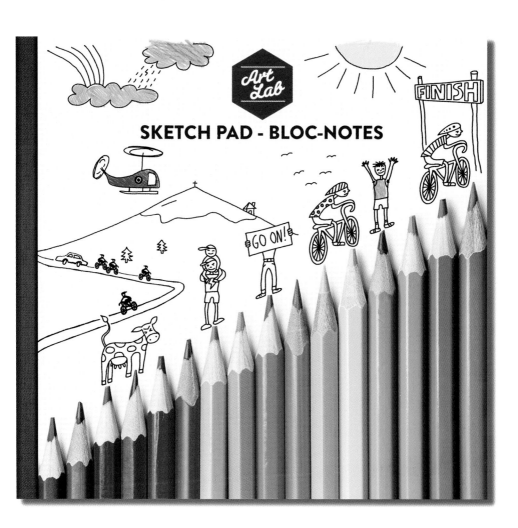

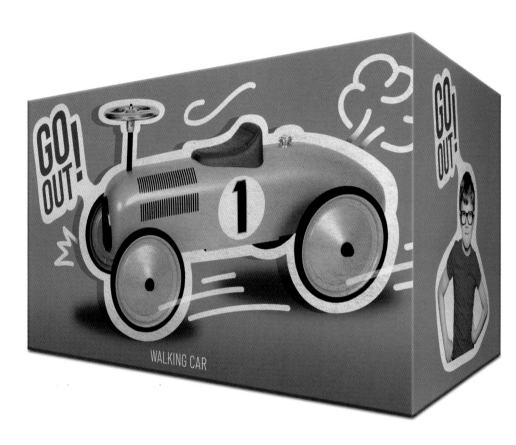

WALKING CAR

Studio Kluif designed the packaging range for the 'Go Out!' toy collection which is brought by the international retailer Blokker. The total 'Go Out!' product range excists of 85 SKU's. 'Go out! The best days end in dirty clothes', is a simple and clear message. The design for this product range is also simple and clear. In this range the product is the hero. Kluif only added a strong background colour and a cartoon-like illustration which makes the packaging vibrant and adds some playfullness. Strong, simple, direct, colourfull, iconic and playfull... Let's Go Out!

78-81 client blokker, amsterdam **project** 'go out!' toys packaging range **year** 2019 **award** gold pentawards 2019

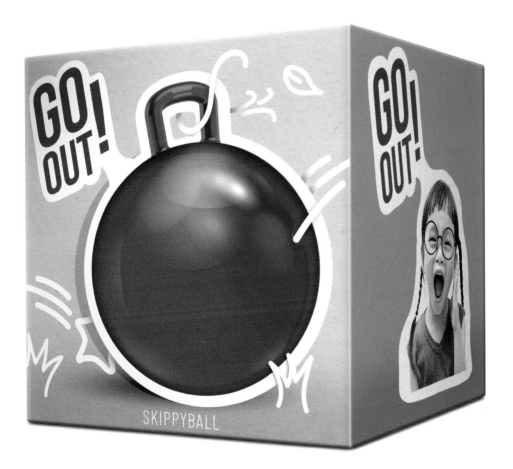

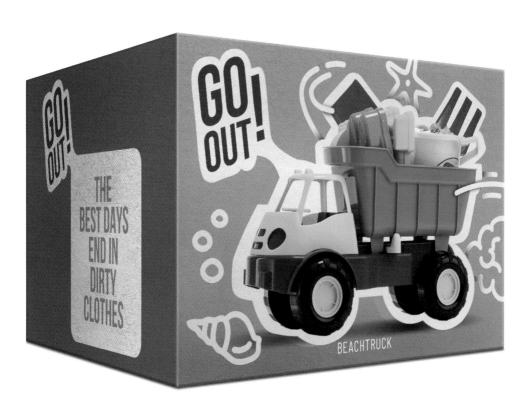

GO OUT!

THE BEST DAYS END IN DIRTY CLOTHES

BEACHTRUCK

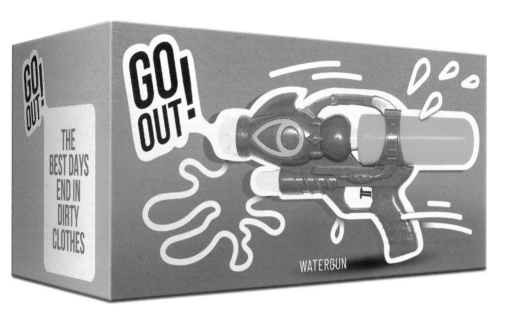

GO!
OUT!

GO!
OUT!

THE
BEST DAYS
END IN
DIRTY
CLOTHES

WATERGUN

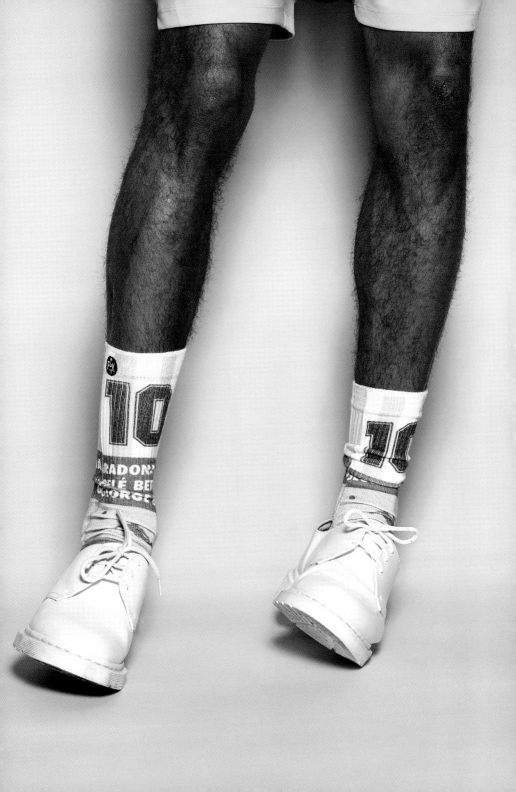

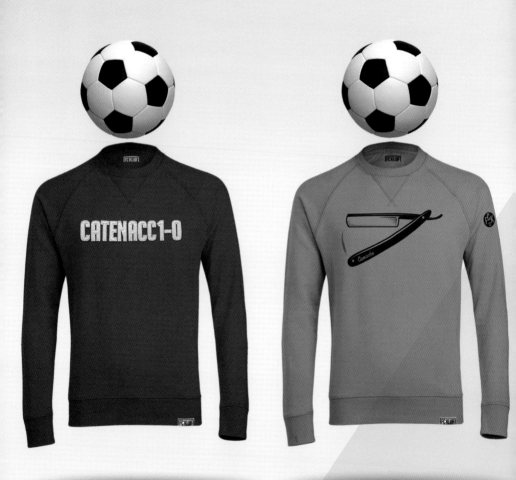

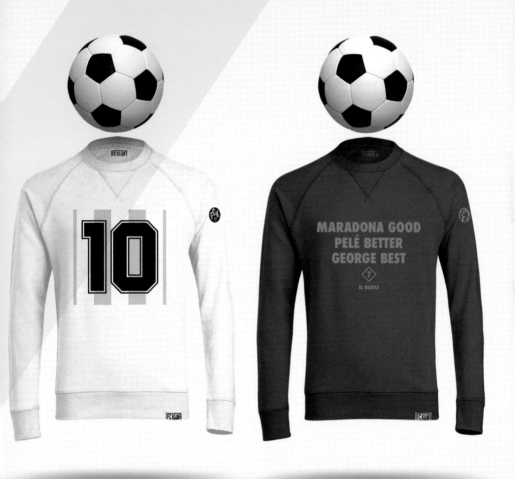

A
BLOOMDALE
FOR EVERY
FACE

A
BLOOMDALE
FOR EVERY
FACE

Bloomdale is an eyewear brand that doesn't follow the typical brand codes. Instead of using photography, like most brands do to promote their new models, Studio Kluif advised to communicate in another way. A series of iconic portraits was developed to underline the brands tag line, 'A Bloomdale for every face'. These portraits play an important role in all communication. In order to create a more extensive brand experience, Kluif created a packaging range with which the optician makes a more personal statement towards the client. Each box can be fitted with a different portrait depending the client is male, female or even a child.

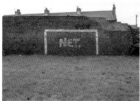
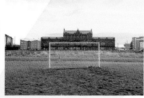
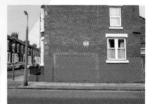

URBAN GOALS
United Kingdom

A stirring memento of lost youth and stark reminder
of the social inequalities still faced in Britain today.

MICHAEL KIRKHAM

Liverpool is a huge breeding ground for talent. The Merseyside region produces almost as many professional football players as the city of London. Boys like Wayne Rooney, Steven Gerrard, Robbie Fowler, Joey Barton, Ross Barkley and Leighton Baines learned to play football on the street. They shot their worn-out football thousands of times at the intersection of the so-called urban goals, captured by photographer Michael Kirkham from Liverpool. 'Liverpool is a city that still has enormous poverty and deterioration in the suburbs,' Kirkham said. 'The city has been in need of a major refurbishment for decades, but we are being overlooked by the government. This ensures that children become creative and spend a lot of time outdoors.'

90-95 client michael kirkham, liverpool **project** book 'urban goals' **year** 2019

Few relics of childhood stir as an Urban Goal does. The crumbling brick. The ghost-like aura. The subtle nuances from goalmouth-to-goalmouth. They are icons of inner city life. Mementos of innumerable 'happy hours', before boys and girls found alcopops.

"I am not sure about the academy system most clubs have — what is the point of trying to discipline a seven year old? You have to let them find their own game. I never changed my game — people have to do what they feel comfortable with."
— Paul "Gazza" Cascoigne —

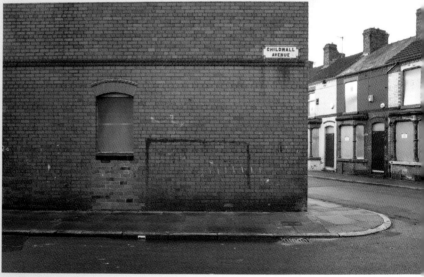

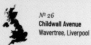 Nº 26
Childwall Avenue
Wavertree, Liverpool

INTRODUCTION
What's life without goals

Reminding us of our halcyon youth, Urban Goals transport to a
time when being the next Robbie Fowler or playing at Wembley
was a distinct possibility. Within its stout frame lies football's
romance; breathing in a different realm to astronomical TV deals
and Sepp Blatter. A place where the game is still beautiful.
The sight of an Urban Goal doesn't just evoke dough-eyed
sentimentalism. Their fading paint reflects the dislocation of
football from the working class neighbourhoods you'll find them
in; the same neighbourhoods most professional clubs grew out
of. They expose economic and cultural truths.
Look hard enough and you'll see inequality, disadvantage and the
eyes of the disenfranchised. Their existence in the twenty-first
century paints a striking picture of social progress in Britain.
Children are still wanting. Yet it's the kids of these goals that
will rise to the apex of the game. The Craig Bellamy's and Wayne
Rooney's of the world. Look harder and you'll see dreams.

Michael Kirkham
Photographer

N⁰ 27
Parkwood Springs Park
Parkwood Springs, Sheffield

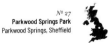

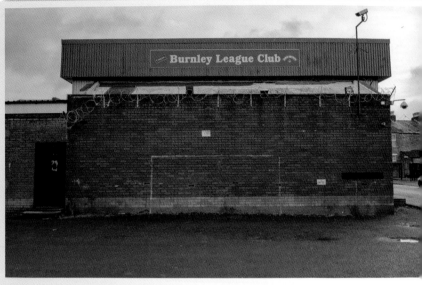

Nº 66
Richard Street
Bankhall, Burnley

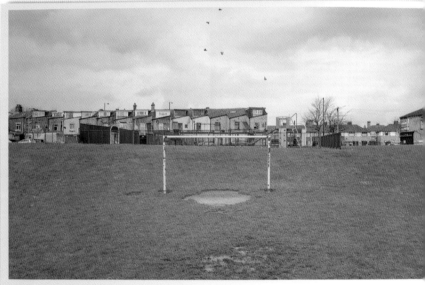

Nº 48
Wensley Road
Coley Park, Reading

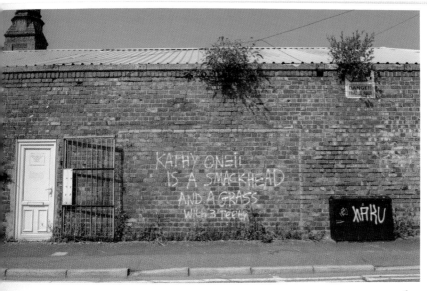

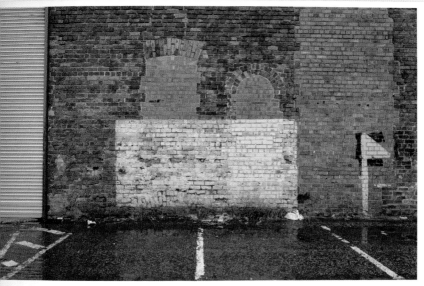

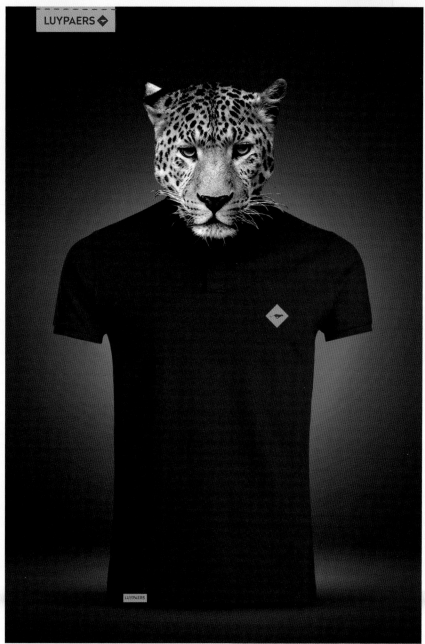

96-101 client luypaers exclusive fireworks, maaseik **project** luypaers merchandise campaign, cake packaging range, whiskey bottle **year** 2018 **awards** silver pentawards 2018, nomination communicatieprijs brabant 2019

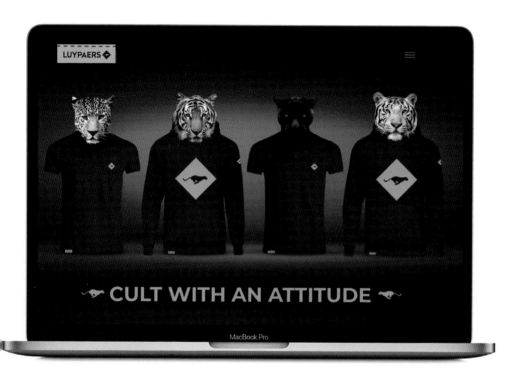

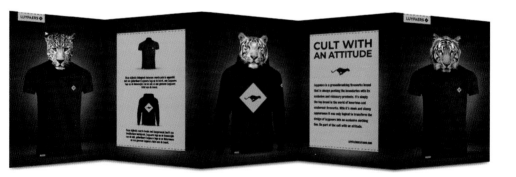

Luypaers is a groundbreaking fireworks brand that is always pushing the boundaries with its exclusive and visionary products. It's simply the top brand in the world of luxurious and exuberant fireworks. With its sleek and classy appearance it was only logical to transform the design of Luypaers into an exclusive clothing line. Studio Kluif not only designed the clothing but also the total visual appearance for this brand. Be part of the cult with an attitude.

LUYPAERS

◆

EXCLUSIVE FIREWORKS

KILIMANJARO LEOPARD
19 SHOTS

19 SCHOTS CAKE MET RODE, LILA, GROENE EN BLAUWE STAARTEN DIE UITEEN SPATTEN IN EEN DAHLIA VAN DEZE KLEUREN, EN WORDEN OPGEVOLGD DOOR WITTE, GROENE, RODE EN GOUDEN GLITTER STROBE.

TERENGGANU PANTHER
52 SHOTS

52 SCHOTS CAKE MET RODE, LILA, ORANJE EN
GELE STAARTEN DIE UITEEN SPATTEN IN EEN
DAHLIA VAN DEZE KLEUREN, EN WORDEN
OPGEVOLGD DOOR WITTE, GROENE, RODE EN
GOUDEN GLITTER STROBE.

LUYPAERS

EXCLUSIVE
FIREWORKS

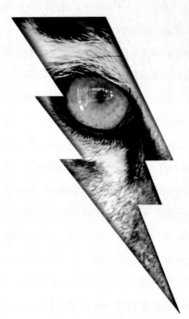

LUYPAERS ◆ **EXCLUSIVE FIREWORKS**

WHITE
SIBERIAN
TIGER
24 SHOTS

24 SCHOTS CAKE MET RODE, LILA, GROENE EN
BLAUWE STAARTEN DIE UITEEN SPATTEN IN
EEN DAHLIA VAN DEZE KLEUREN, EN WORDEN
OPGEVOLGD DOOR WITTE, GROENE, RODE EN
GOUDEN GLITTER STROBE.

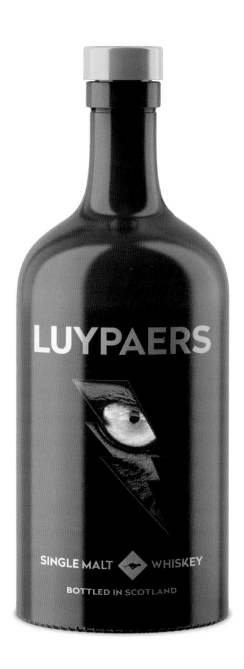

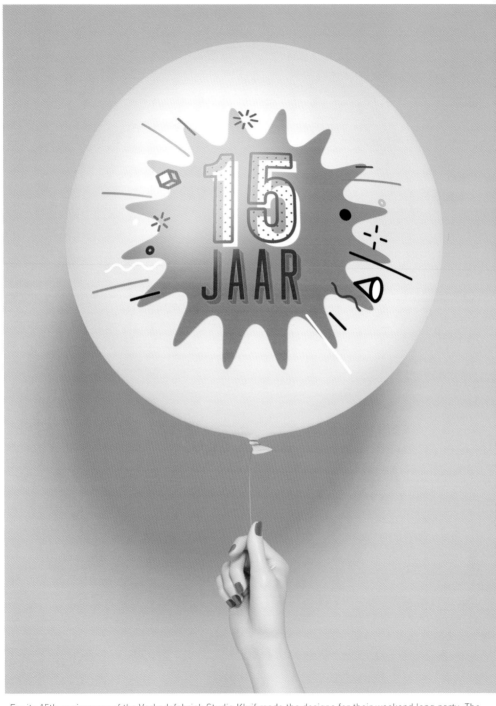

For its 15th anniversary of the Verkadefabriek Studio Kluif made the designs for their weekend long party. The colourful graphic party cake containing the acts and performances of the 24 hour program was used on several media such as posters, flyers and digital content.

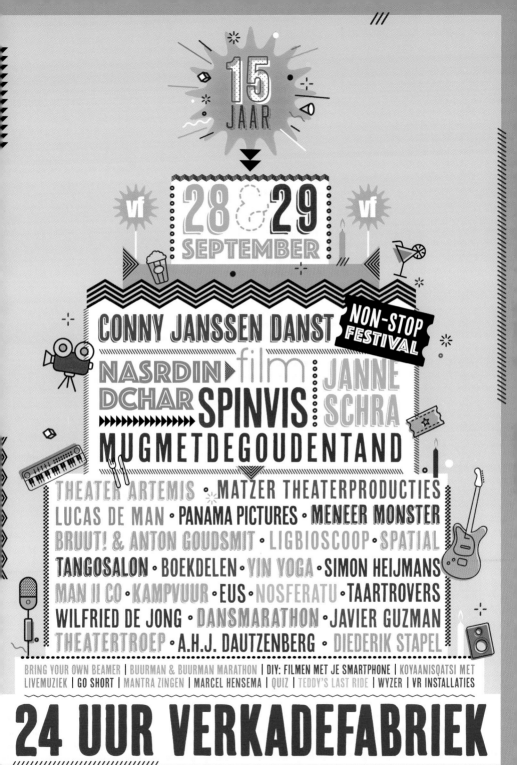

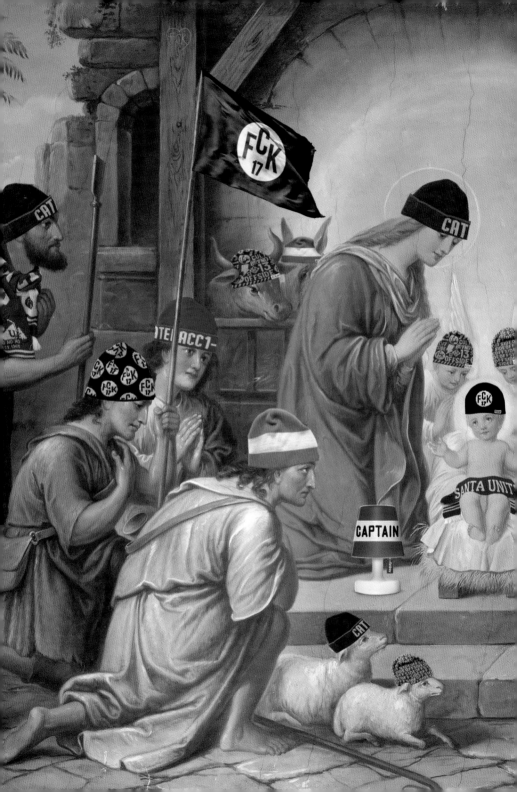

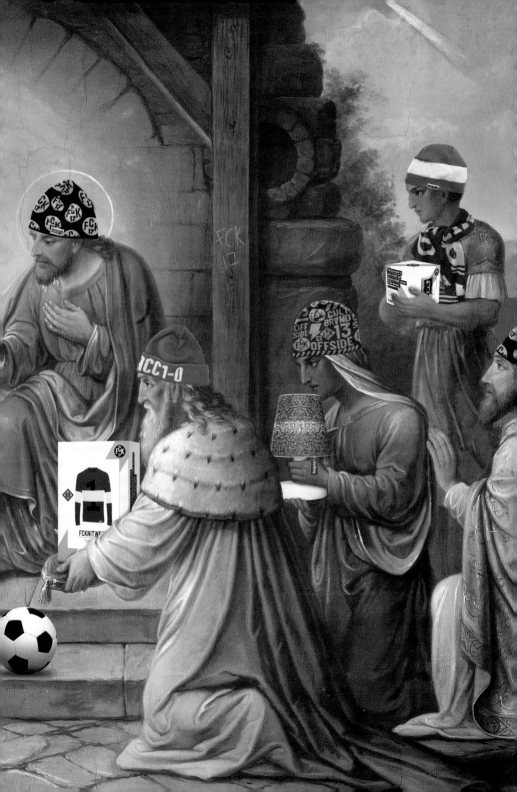

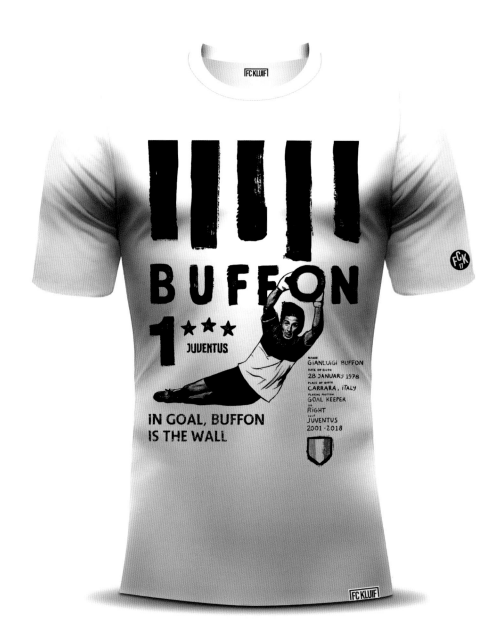

FCK designed a special edition shirt and poster for the legend of Turin! Gianluigi 'The Wall' Buffon. The best goalkeeper of all time.

104-105 client fc kluif, 's-hertogenbosch **project** fck christmas mailing 'football, the new religion' **year** 2018
106-107 client fc kluif, 's-hertogenbosch **project** buffon t-shirt & poster **year** 2018 **awards** silver pentawards 2018, nomination bonk 2018

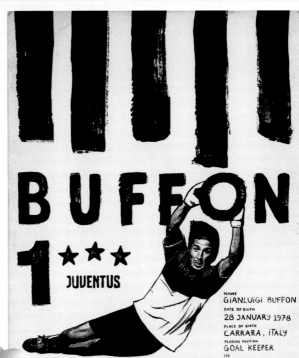

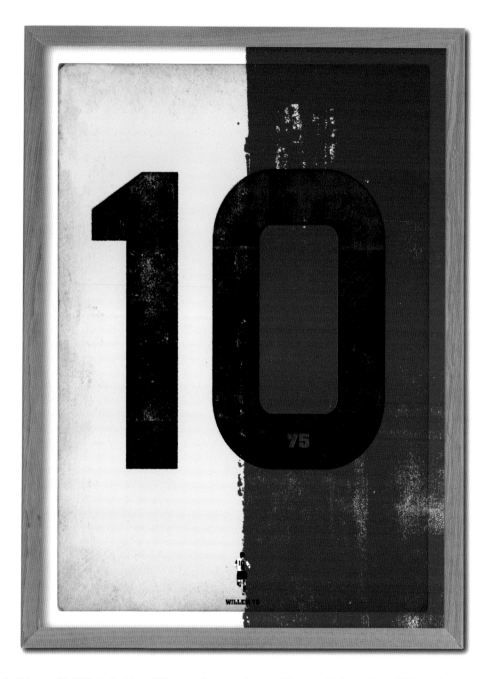

On February 20, 2019, football icon Willem van Hanegem became 75 years old. According to FCK, van Hanegem was the best midfielder the Netherlands ever produced. FCK celebrated Willem's birthday with a beautiful poster and shirt.

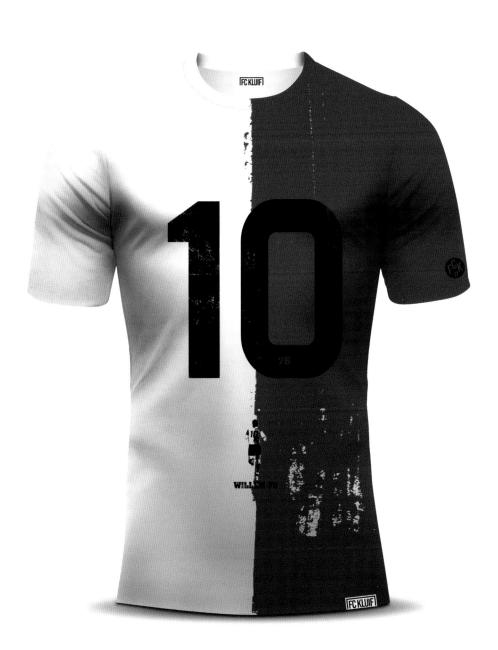

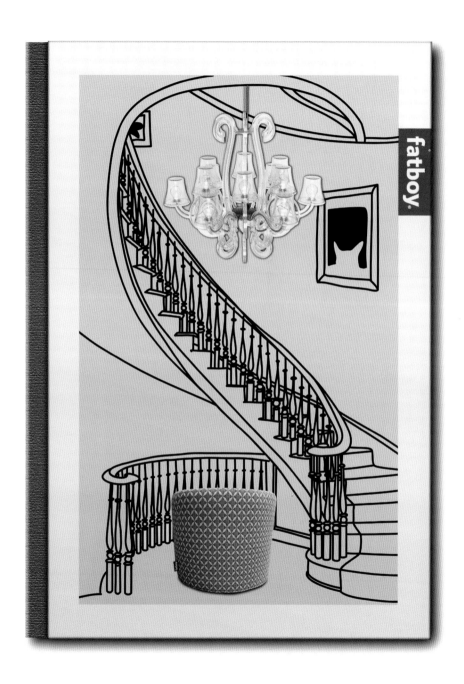

For the Fatboy lamp collection brochure Studio Kluif made line drawings of situations in which the lamps could be placed.

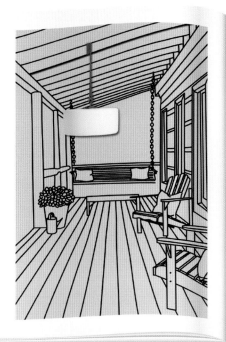

THIERRY
LE SWINGER

A multifunctional LED lamp. The supplied line makes it easy to suspend your Thierry anywhere, from a parasol for example. You can also anchor Thierry into the ground by using the specially developed beach wood stand. Position it on the beach or use it during a picnic on the grass.

Indoor Outdoor

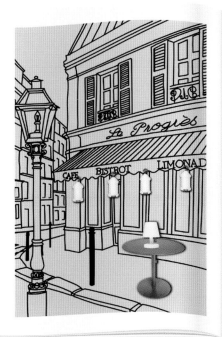

LAMPIE-
ON

Celebrate life. Whatever the occasion: the Lampie-on celebrates with you. Wireless and portable. Convenient both indoors and out. Make rooms, gardens, pools and parties more beautiful. An enhancement for every moment. Hang it up, sit back. The Lampie-on provides a memorable light experience.

Indoor Outdoor

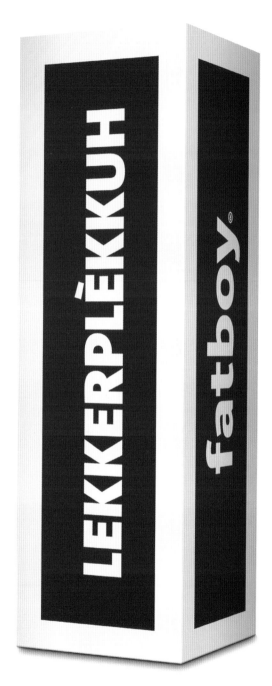

Studio Kluif came up with a product idea for Fatboy: Lekkerplèkkuh! With Lekkerplèkkuh you can personalise your windows with large stickers. Easy to apply, repositionable, mess free. By using Lekkerplèkkuh you can transform your windows into something uniquely wonderful.

112-113 client fatboy, 's-hertogenbosch **project** lekkerplèkkuh window stickers **year** 2018

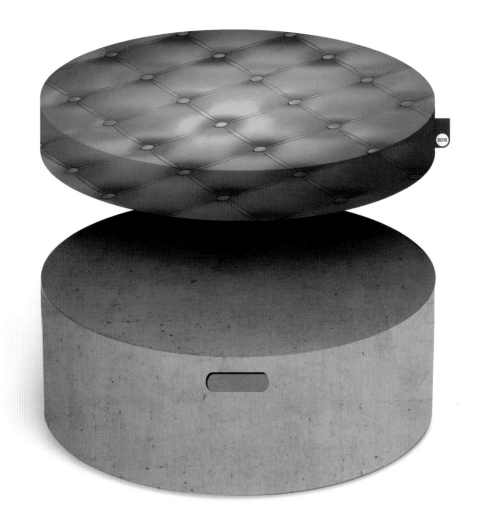

At Suns form and function melt together in a piece of furniture to enjoy time after time. Suns takes design seriously. The result is outdoor furniture with a taste. Positive, authentic and just that little different. With this attitude Kluif designed a Suns ottoman collection. The ottoman consists of a simple rounded base which you can give a personal touch with a colourful cushion.

114-115 client suns, vught **project** ottoman collection **year** 2019

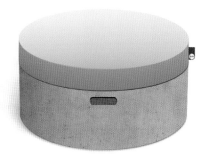
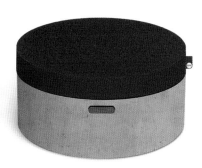
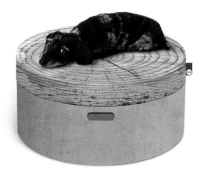

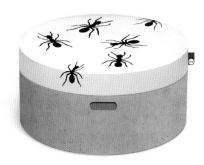
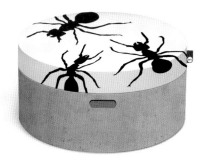

baby wash gel
soap free

Moisturizes
the skin

blokker.

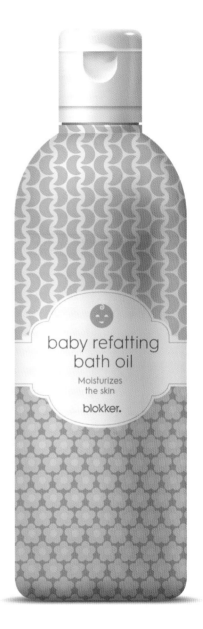

baby refatting
bath oil

Moisturizes
the skin

blokker.

Kluif designed the new baby care packaging range for Blokker. The soft coloured pattern designs are also used on various products like baby bodysuits, baby toys, diaper bags and more.

116-119 client blokker, amsterdam **project** baby care packaging and product range **year** 2019

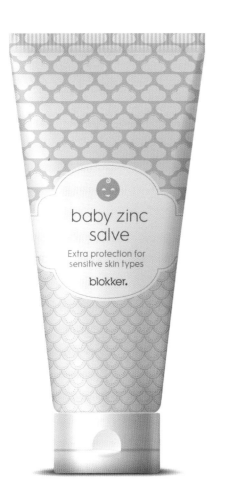

baby zinc
salve

Extra protection for
sensitive skin types

blokker.

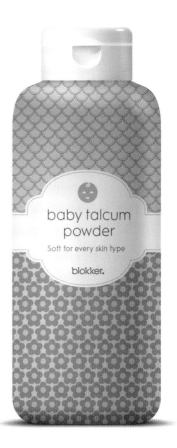

baby talcum
powder

Soft for every skin type

blokker.

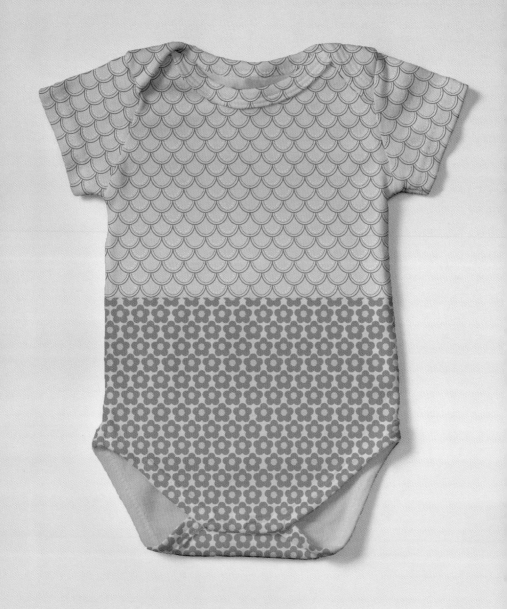

my first year

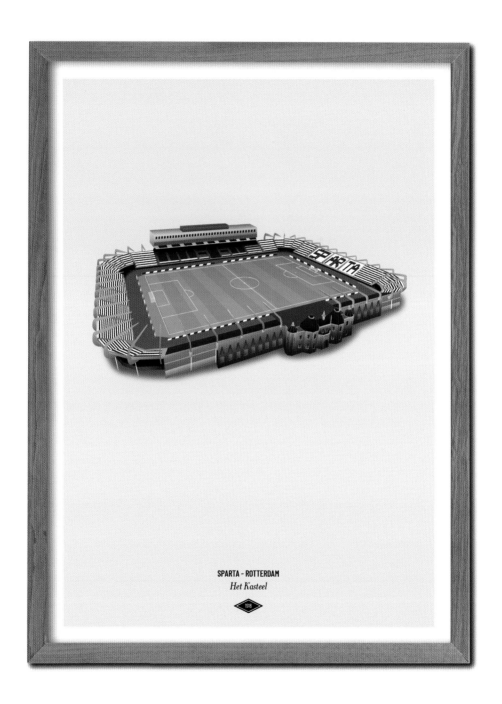

SPARTA - ROTTERDAM
Het Kasteel

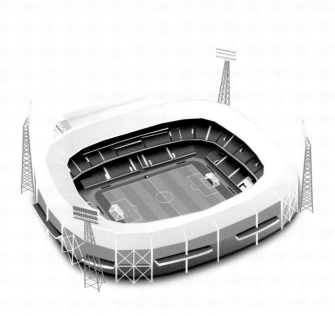

FEYENOORD - ROTTERDAM

De Kuip

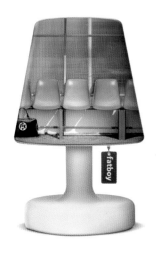

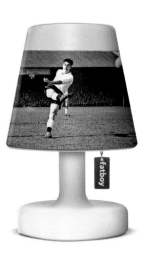
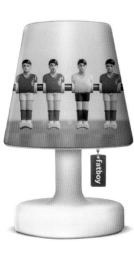

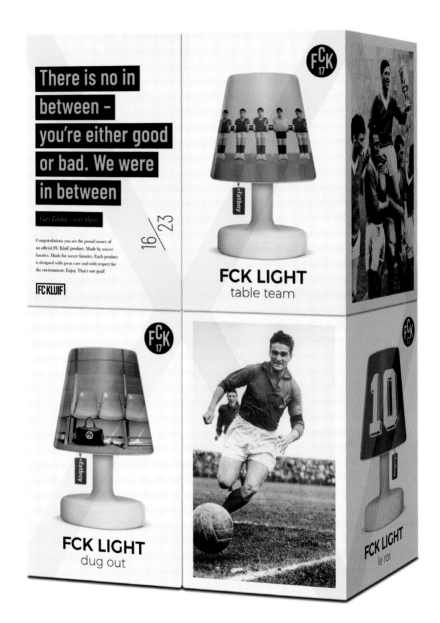

There is no in between – you're either good or bad. We were in between

Guus Laseker, soccer player

Congratulations you are the proud owner of an official FC Kluif product. Made by soccer fanatics. Made for soccer fanatics. Each product is designed with great care and with respect for the environment. Enjoy. That's our goal!

FC KLUIF

16/23

FCK LIGHT
table team

FCK LIGHT
dug out

FCK LIGHT
le roi

In co-operation with Fatboy, FC Kluif has designed a lamp collection. Introducing the mobile table lamp you've always wanted. This small white table lamp with an FCK Cappie brings the right amount of light into the darkness and football into your home. If football is the light of your life, this lamp is a must-have.

122-123 client fc kluif, 's-hertogenbosch **project** fck lamp collection **year** 2018 **awards** silver pentawards 2018, nomination bonk 2018

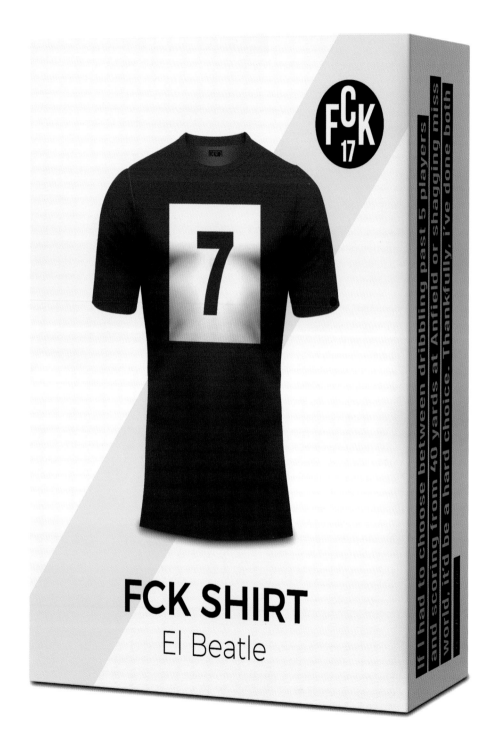

If I had to choose between dribbling past 5 players and scoring from 40 yards at Anfield or shagging miss world, it'd be a hard choice. Thankfully, i've done both

FCK SHIRT
El Beatle

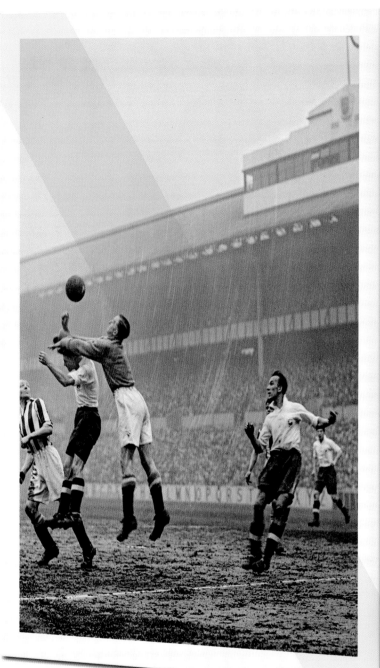

07/23

FC KLUIF

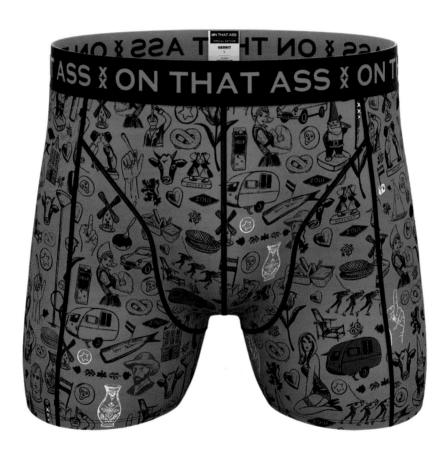

Every month a unique distinctive design, that's the slogan for the young and dynamic boxer brand On That Ass. Founded in September 2015, their main focus for their shorts is the youthful social media man. The brand mainly uses channels like Instagram and Facebook to reach its target audience. Kluif designs prints for the On That Ass boxers.

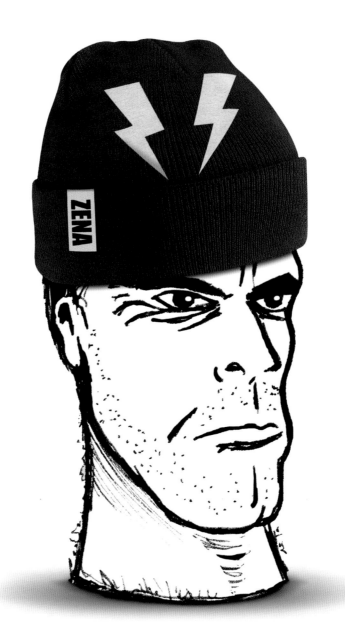

For years Zena has been the leading brand for badass fireworks. Their motto 'Harder, Better, Faster' says it all: original mind-blowing fireworks that make an everlasting impression. For all true Zena lovers that want to show off that they live and breath fireworks 24/7 Studio Kluif designed a line of shirts, sweaters and caps to compliment their lifestyle. Studio Kluif was also responsible for all the communication about this brand.

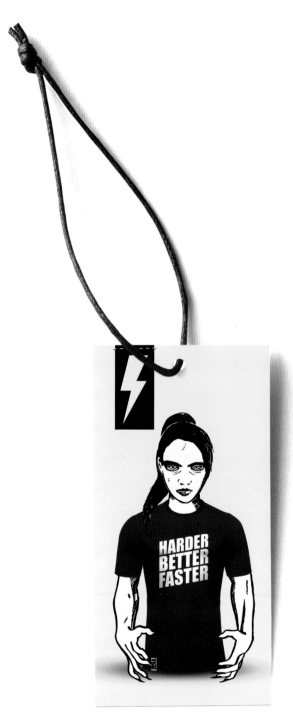

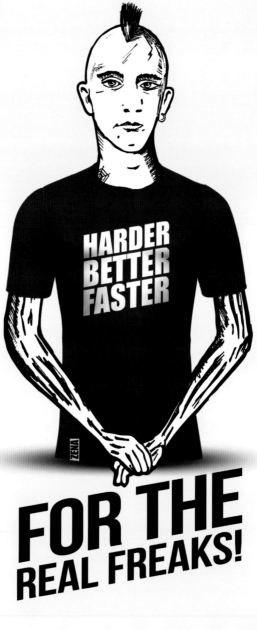

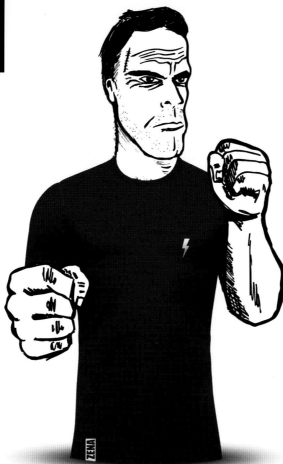

Aangeboden
Eredivisie middenstippen op aanvraag
(binnen 24 uur vers geschept)

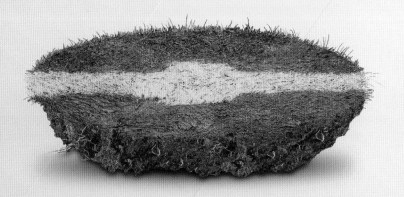

FCK
17

Voor meer unieke voetbalproducten
ga naar **fckluif.nl**

FC KLUIF

134-135 client fc kluif, 's-hertogenbosch **project** advertising campaign **year** 2018 **awards** silver pentawards 2018, nomination bonk 2018

Weltmeister

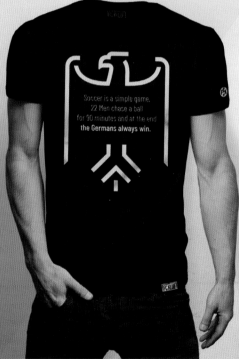

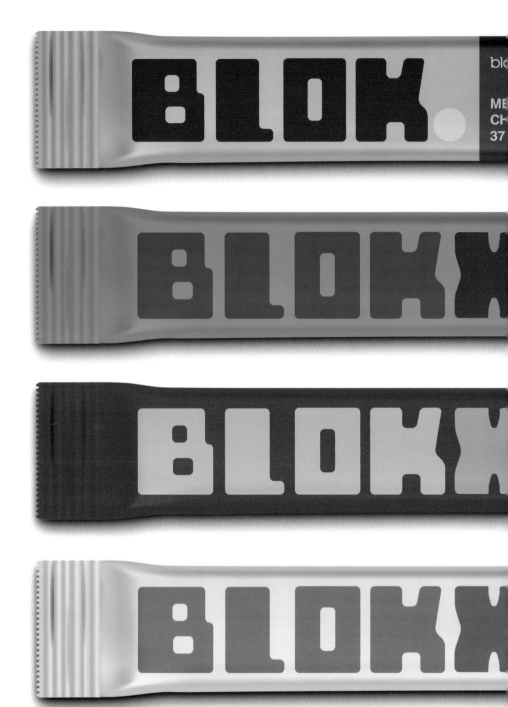

For the series of Blokker chocolate bars the idea for the design was fairly simple. The bigger the bar the more XL the name on the label.

blokker.

**HAZELNOOT
CHOCOLADE
37% CACAO**

XL. blokker.

**PUUR
CHOCOLADE
65% CACAO**

XXL. blokker.

**PUUR
CHOCOLADE
80% CACAO**

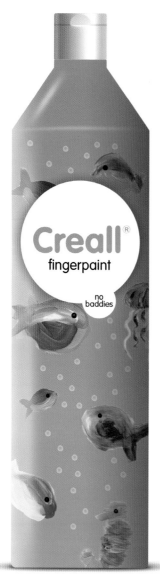
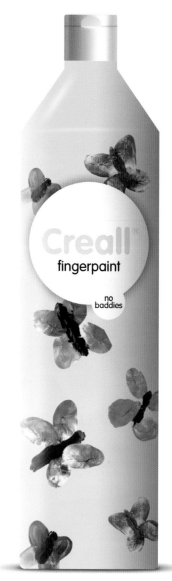

Whether it is at home or in the classroom, being creative makes you smarter and creates cheerfulness and relaxation! Creall has been developing and producing safe, responsible and inspiring creative products for more than fifty years. Studio Kluif has developed a new packaging concept for Creall fingerpaint in collaboration with Prouddesign Amsterdam. Each product label has been given an illustration that matches the colour in the bottle. The universe for black, an ocean for blue, a jungle for green, and so on. The illustrations are made with the actual finger paint and thus shows what can be made with the product in an imaginative way.

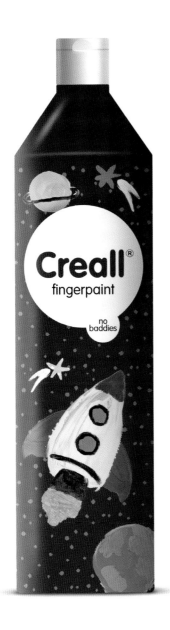
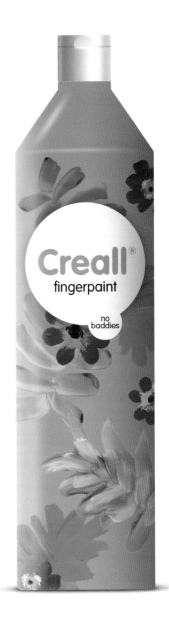

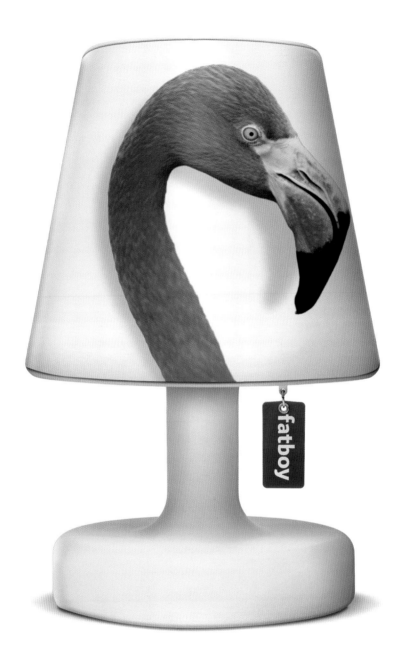

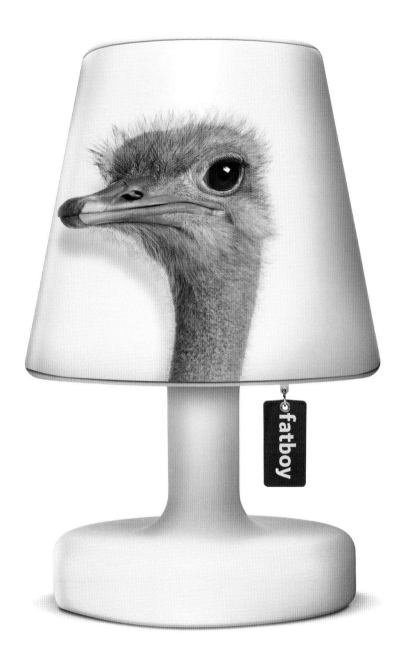

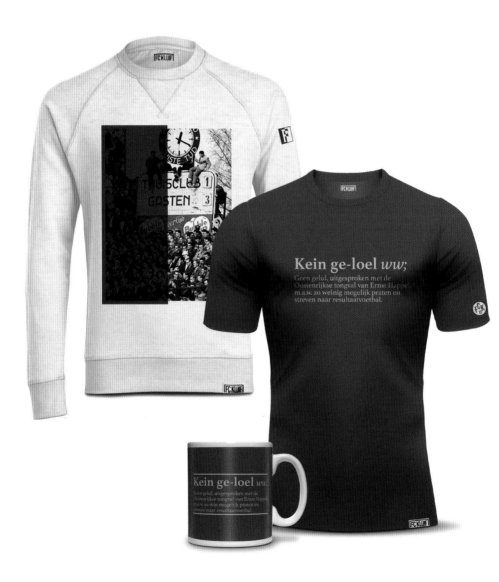

One of the concepts of FCK is the Club Special Collaboration. At FCK we design and produce top-level products for football club fanshops worldwide. In close collaboration with the club we design a special edition FCK Club Collection. Only for supporters with a real 'club heart'!

142-143 client fc kluif, 's-hertogenbosch **project** fck club special feyenoord **year** 2018 **awards** silver pentawards 2018, nomination bonk 2018

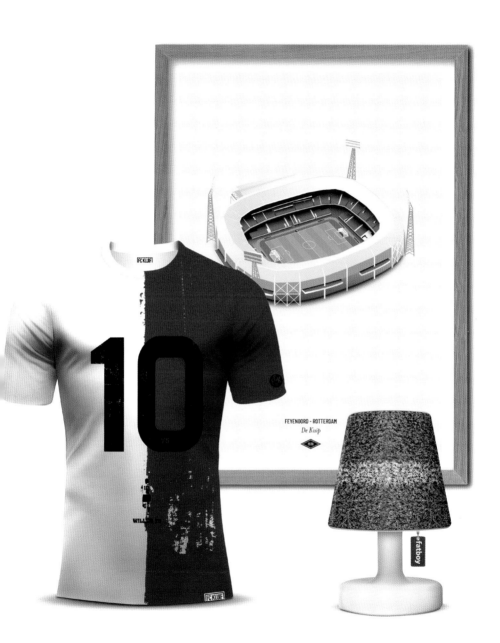

FEYENOORD - ROTTERDAM
De Kuip

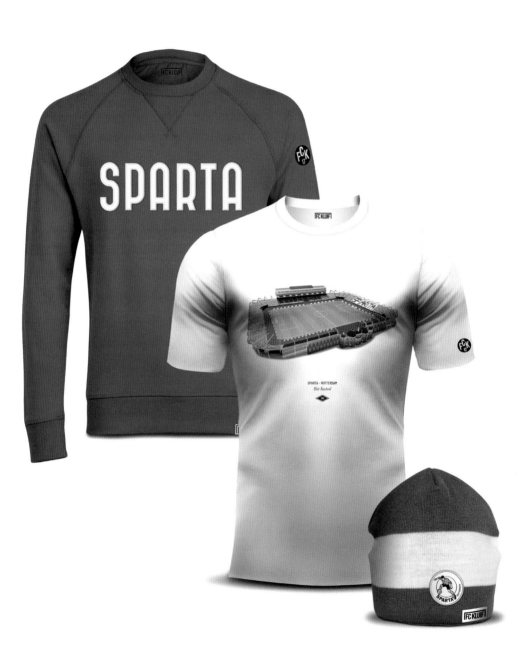

144-145 client fc kluif, 's-hertogenbosch **project** fck club special sparta **year** 2018 **awards** silver pentawards 2018, nomination bonk 2018

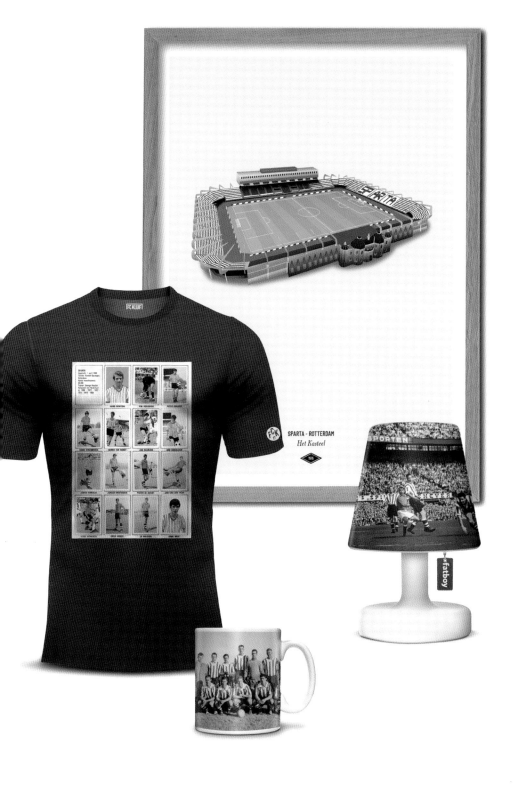

SPARTA - ROTTERDAM
Het Kasteel

The municipality of Amstelveen chose Studio Kluif to develop the new city marketing identity. Amstelveen, also known as the garden of Amsterdam, is a green city with international allure, a rich cultural life and a vibrant city center. After having done similar projects for the municipalities of 's-Hertogenbosch, Ede and the province of Flevoland, Studio Kluif developed an identity aimed at awareness among the residents of this surprisingly lively city.

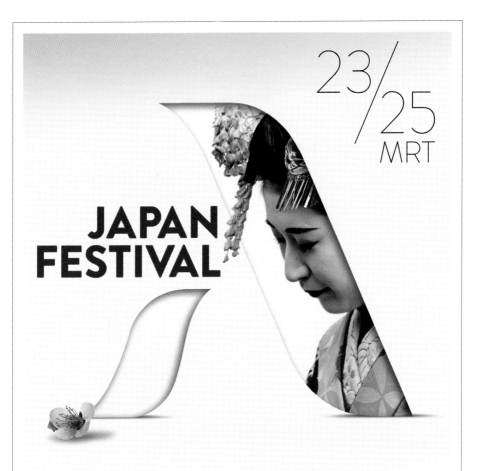

JAPAN FESTIVAL

DOMPEL JE ONDER
IN JAPANSE SFEREN

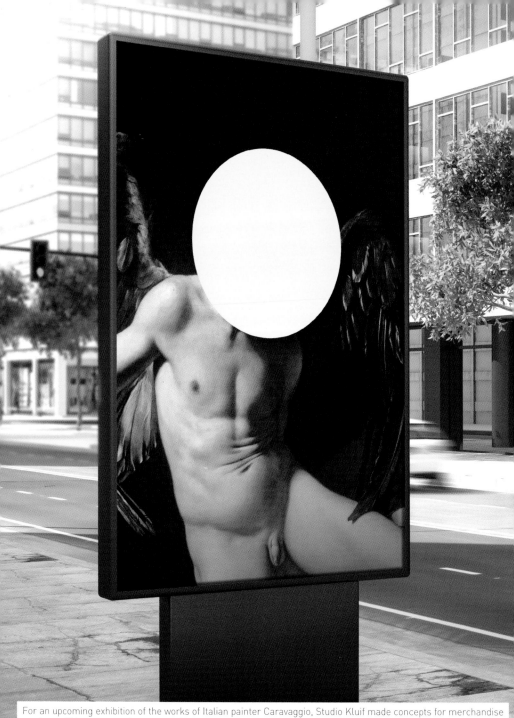

For an upcoming exhibition of the works of Italian painter Caravaggio, Studio Kluif made concepts for merchandise products. This poster series was made as a teaser for the exhibition. At first, an image with only a yellow dot appeared, leaving the spectator with questions. Just before the launch another poster would appear revealing the part of the image that was blocked out and the actual information about the exhibition.

148-149 client bekking & blitz, amersfoort **project** 'caravaggio' poster series concept **year** 2019

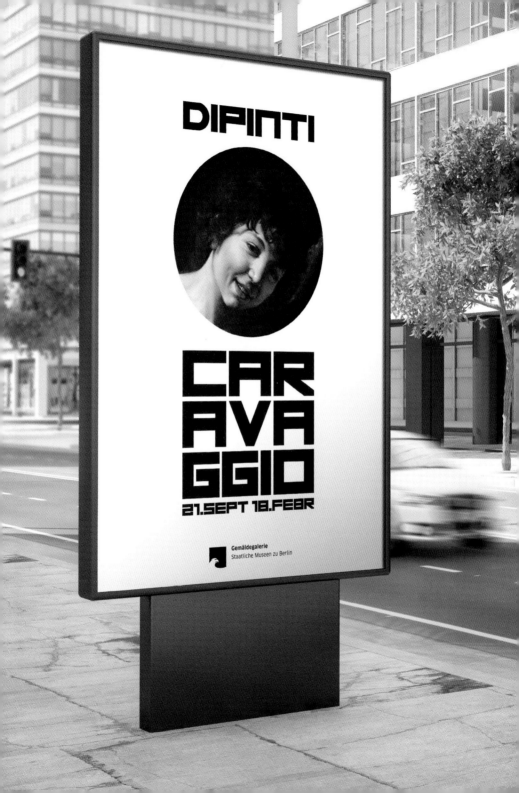

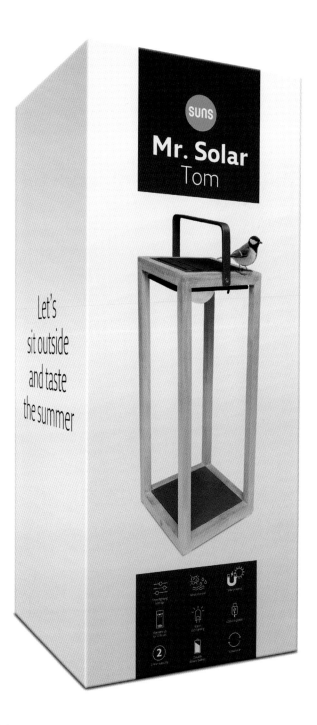

For the Suns Mr. Solar range Studio Kluif has made a packaging design on which the lamp is shown in both light and dark.

150-151 client suns, vught **project** mr. solar packaging range **year** 2019

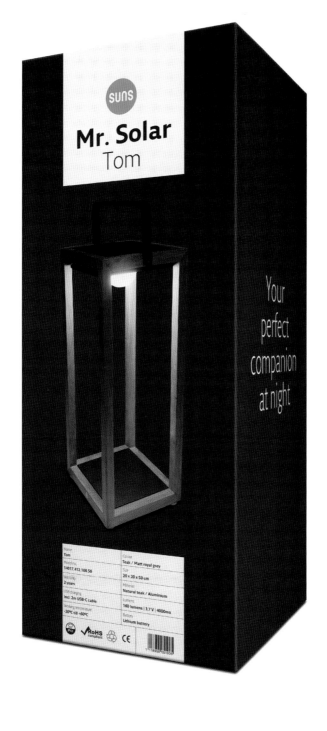

SUNS

Mr. Solar
Tom

Your
perfect
companion
at night

Name	Colour		
Tom	Teak / Matt royal grey		
Model no.	Size		
14017.412.108.58	20 x 20 x 50 cm		
Warranty	Material		
2 years	Natural teak / Aluminium		
USB charging	Lumens		
Incl. 2m USB-C cable	160 lumens	3.7 V	4000ma
Working temperature	Battery		
-20°C till +60°C	Lithium battery		

RoHS compliant CE

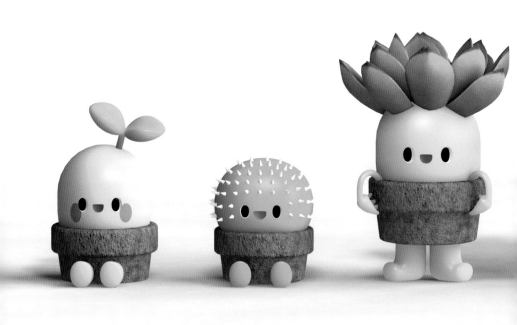

Kluif designed the 'Leafy' family for Intratuin. These characters play an important role in the communication of Intratuin. They provide customers with product information or advise them how to take care of plants, garden tools, etc. The Leafy family is used in various digital media, but also in print media.

152-153 client intratuin, woerden **project** mascot 'leafy' **year** 2019

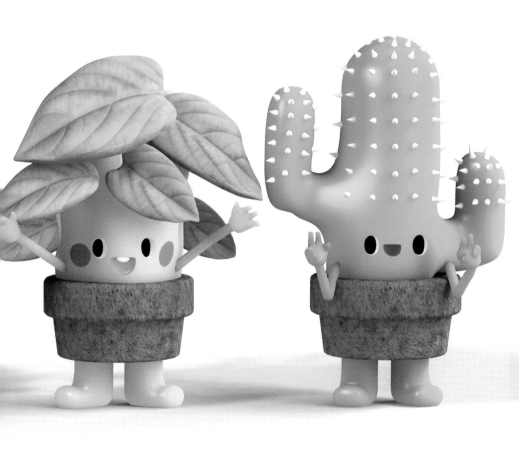

WHAT IS THE MEANEST THING YOU EVER DID?

GRATITUDE

WHAT DO OTHER PEOPLE FIND ATTRACTIVE ABOUT YOU?

HOW WOULD YOU REWARD YOURSELF?

INSPIRATION

TELL US A DIRTY SECRET!

WHAT IS YOUR FAVORITE DANCE MUSIC?

FORGIVENESS

IF YOU COULD HAVE DINNER WITH ANYBODY, WHO WOULD IT BE?

WHO WAS THE FIRST PERSON YOU KISSED?

COMPASSION

WHICH MOVIE MADE YOU CRY?

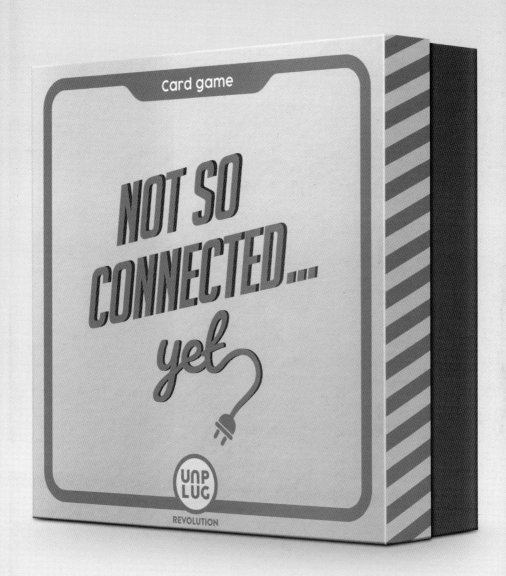

In a society that's more and more dominated by digital communication, people tend to forget that 'offline' interaction is the best way to really connect to one another. By answering the questions asked on the diversely themed cards the players are encouraged to share stories and secrets, discuss opinions and differences and above all stimulate each other to have genuine conversations. No smartphones allowed.

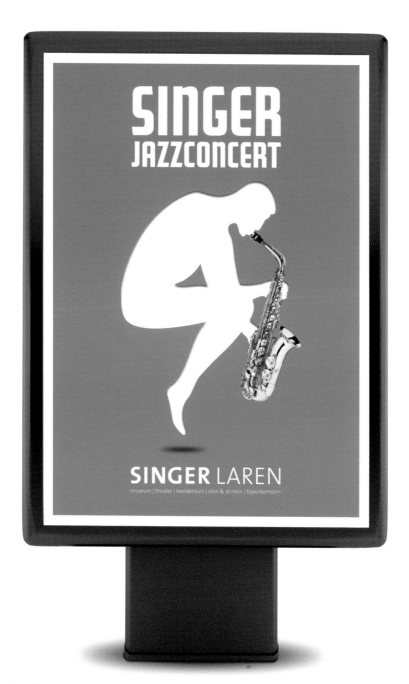

The icon of the Singer Laren museum is the famous statue 'The Thinker' (Le Penseur) by Rodin. Every year the Singer museum organizes a jazz concert. By combining iconic jazz instruments, such as a sax or trumpet, with the Singer icon, this strong and clear poster series was created.

156-157 client singer laren, laren **project** jazz concert posters **year** 2019

SINGER
JAZZCONCERT

SINGER LAREN

museum | theater | beeldentuin | eten & drinken | bijeenkomsten

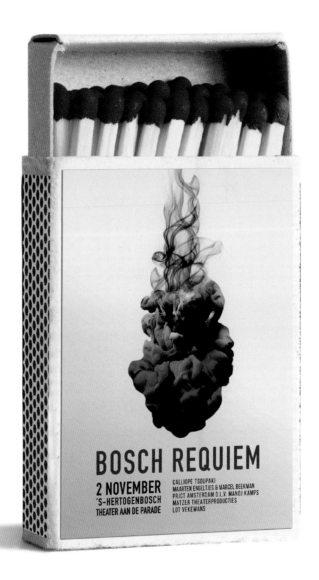

With its dark milky cloud, the main image for the 2019 Bosch Requiem Concert appeals to the feeling of mourning and loss. A box of matches was used as give away during the concert so people could use this to light incense during the commemoration of their loved ones.

158-159 client november music, 's-hertogenbosch **project** 'bosch requiem' poster and give away **year** 2019

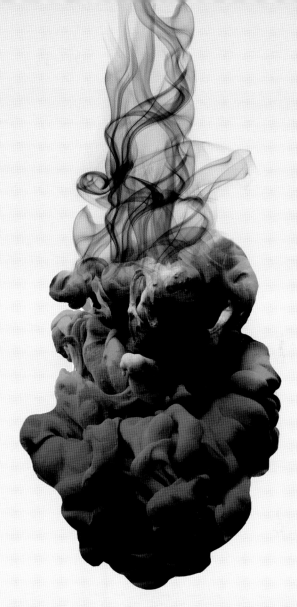

BOSCH REQUIEM

2 NOVEMBER
'S-HERTOGENBOSCH
THEATER AAN DE PARADE

CALLIOPE TSOUPAKI
MAARTEN ENGELTJES & MARCEL BEEKMAN
PRJCT AMSTERDAM O.L.V. MANOJ KAMPS
MATZER THEATERPRODUCTIES
LOT VEKEMANS

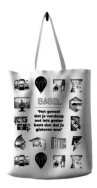

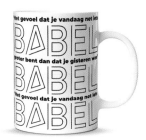

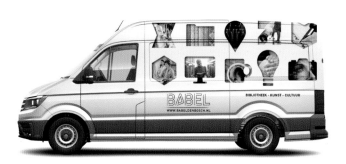

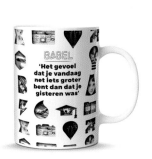
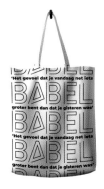

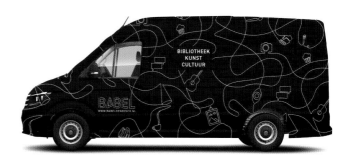
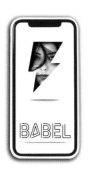

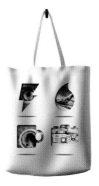

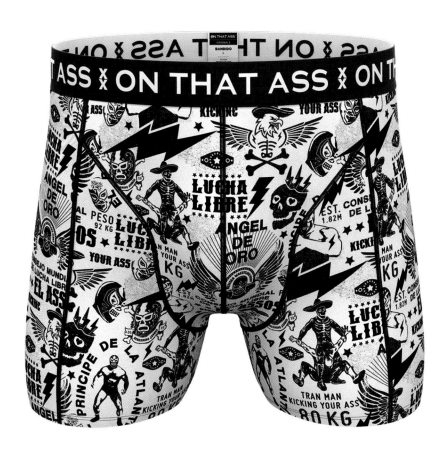

ON DE LA ÁSSOS

LOS CAMPEONES DE LUCHA LIBRE

EST.
1.84M

0 7 3

EST.
1.87M

ENTRADO POR

GRAN HERMANOS - SATÁ KOENOS - FRANCO VANGALOS - EL KUIFOS

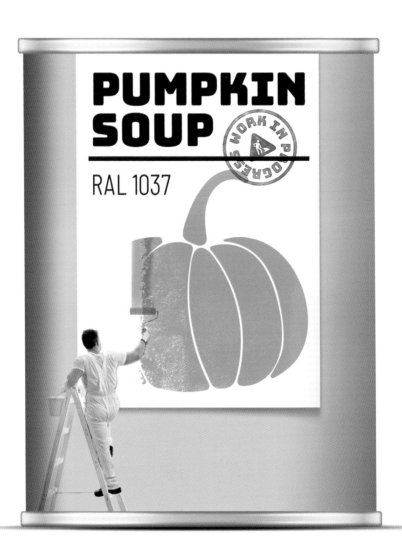

Bickery Food Group is a company that produces and provides Christmas giftboxes for varied companies. Especially for companies in the business of construction Kluif made the packaging for a series of food products which was themed 'Work in Progress'.

164-165 client bickery food group, 's-graveland **project** 'work in progress' packaging range **year** 2019

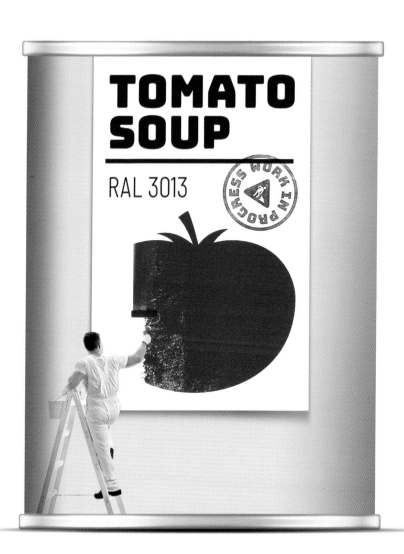

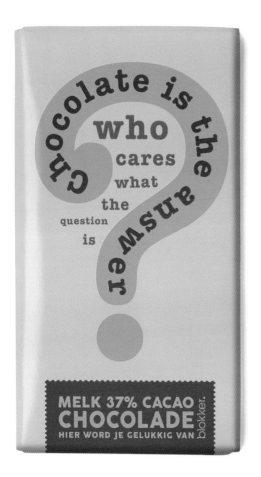

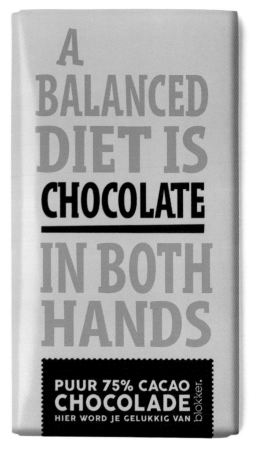

For a series of chocolate products, Studio Kluif decided to emphasize the feeling that is being evoked by people eating chocolate. The quotes on the labels are more important than the actual product information and put a smile on your face.

166-167 client blokker, amsterdam **project** chocolate bar packaging range concept **year** 2019

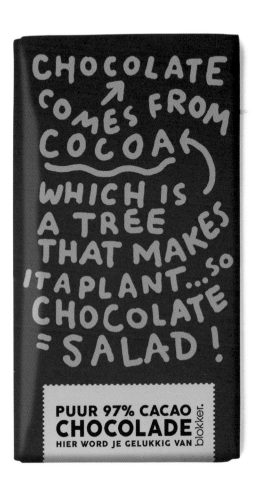

CHOCOLATE
COMES FROM
COCOA
WHICH IS
A TREE
THAT MAKES
IT A PLANT...SO
CHOCOLATE
= SALAD !

PUUR 97% CACAO
CHOCOLADE
HIER WORD JE GELUKKIG VAN blokker.

I COULD
GIVE UP
CHOCOLATE

BUT I'M
NOT A
QUITTER

PUUR 65% CACAO
CHOCOLADE
HIER WORD JE GELUKKIG VAN blokker.

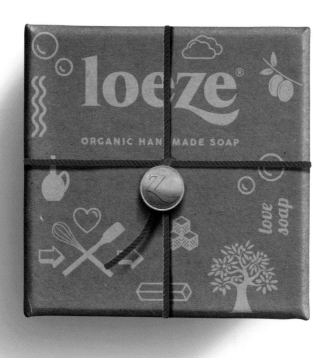

Loeze soap is a brand that produces handmade organic soap. The blocks of soap are packed in a simple wrapping paper. On the inside of the wrapping paper there is an illustration about the honest and sustainable making process.

168-169 client loeze, eindhoven **project** soap packaging **year** 2019
170-171 client studio kluif **project** poster campaign 'dutch design cowboys' book **year** 2019

clean life, clean conscience

ZEEPZIEDEN

MIX &
MATCH

olijfolie

LOVE
SOAP

organic handmade soap

Zeepzieden is gebaseerd op een eeuwenoude zeeptraditie.
Loeze maakt haar zeep volgens de traditionele cold process
methode. Hierdoor blijven de goede eigenschappen van
de ingredienten en de glycerine in de zeep bewaard.

Deze zeep is ontwikkeld om een diepe reiniging te bieden.
Actieve koolpoeder wordt ook wel hetzwarte goud genoemd:
het geeft een lichte scrub, absorbeert onzuiverheden,
wast ze weg en laat je huid fris en zacht aanvoelen.

loeze®

Vind meer informatie over onze producten op www.loeze.com

STUDIO
KLUIF

STUDIO KLUIF

DUTCH DESIGN COWBOYS

OUT NOW! DUTCH DESIGN COWBOYS
BY BIS PUBLISHERS A'DAM

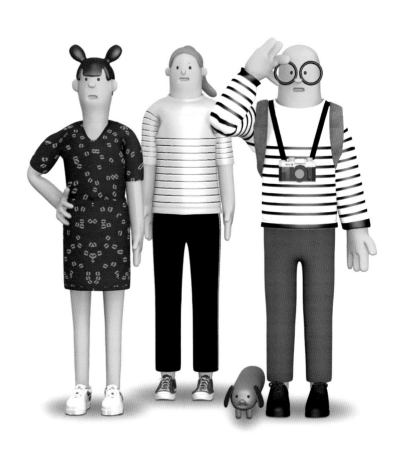

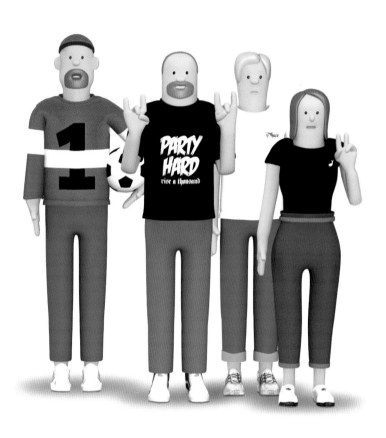

INDEX

AWARDS AND NOMINATIONS

studio kluif corporate identity
nomination dutch corporate identity prize 2001
nedap annual report, 'rules, knowledge and sense'
nomination best dutch annual report 2003
hema packaging baby care products
winner adcn prize (silver lamp) 2003
nomination dutch design awards 2004
nedap annual report, 'work happily'
nomination best dutch annual report 2004
nomination new york festivals 2004
newrulez media corporate identity
nomination dutch design awards 2005
tielen printers calendar
winner dutch calendar prize 2006
nedap annual report, 'innovation'
nomination new york festivals 2006
packaging sisi drinks
nomination san accent 2007, in collaboration
with doom & dickson and combat
hema packaging crafts products, 'art & fun'
merit winner european design awards 2008
nomination adcn prize 2008
hema waffle ice cream sandwich packaging
winner adcn prize 2009
finalist new york festivals 2009
hema choco-kite ice cream packaging
winner adcn prize 2009
finalist new york festivals 2009
nedap annual report, 'we're traveling...'
winner silver european design awards 2009
nomination adcn prize 2009
nomination new york festivals 2009
hema garden & outdoor packaging
selected for dutch design awards 2009
snor publishers, 'lunchbox book'
winner gourmand cookbook awards 2009
bis publishers book, 'eat love'
winner bronze european design awards 2009
winner silver gourmand cookbook awards 2010
nedap annual report, 'endless energy'
winner best dutch annual report 2009
winner silver european design awards 2010
finalist new york festivals 2010
nomination german design award 2012
013 corporate identity
finalist ccb communication prize 2010
hema packaging markers and crayons
nomination adcn prize member jury 2011
nomination adcn prize professionals jury 2011
nedap annual report, 'be different to make the
difference'
finalist new york festivals 2011
jheronimus bosch 500 branding
wolda merit award 2011
poppodium 013 website
best podium website agendainfo award 2011
bis publishers book, 'indie brands'
finalist european design awards 2012
intratuin potting soil packaging
gold pentawards 2012
fatboy product catalogue
winner silver european design awards 2013
nedap annual report 'the art of imagination'
nomination new york festivals 2013
studio kluif christmas poem booklet
nomination new york festivals 2013
hema toothpaste packaging range
silver pentawards 2013
nomobese starterskit
gold pentawards 2013
fatboy second life packaging
nomination pentawards 2013
jheronimus packaging range
platinum pentawards 2013
nomination adcn prize members jury
nomination adcn prize professionals jury

intratuin garden tools packaging range
silver pentawards 2014
blonde poulin printing paper packaging range
platinum pentawards 2014
winner new york festivals 2015
van der burgh handmade chocolate packaging range
gold pentawards 2014
republic of south-korea 'our stories' nation brand
idc eeum design connects award 2016
silver pentawards 2016
kwantum 'wall+' home decoration paint packaging
silver pentawards 2016
jheronimus soap packaging range
nomination pentawards 2016
jheronimus bosch 500
winner communications prize brabant 2016
pet stuff animal supplies packaging range
silver pentawards 2017
intratuin pond pumps packaging range
gold pentawards 2017
kwantum lighting packaging range
gold pentawards 2017
office factory elastic bands packaging range
bronze pentawards 2017
office factory staples packaging range
gold pentawards 2017
uncle orange
winner communicatieprijs brabant 2018
fc kluif
nomination bonk 2018
silver pentawards 2018
luypaers exclusive fireworks packaging range
nomination communicatieprijs brabant 2018
silver pentawards 2018
bloomdale eyewear packaging range
platinum pentawards 2018
lamzac campaign
crossborder award 2018
brand loyalty theme boxes loyalty programs
nomination communicatieprijs brabant 2019
studio kluif painkiller
nomination pentawards 2019
fatboy plat-o packaging range
bronze pentawards 2019
blokker go out! toys packaging range
silver pentawards 2019
southbank watson outfitter uk button-eye shirts
gold pentawards 2019
nomination people's choice award 2019

PUBLICATIONS

360° design, china
'the netherlands'
actar, spain
'super holland design'
adcn 2009, the netherlands
'voor wie je het eigenlijk doet'
adformatie, the netherlands
archive, usa
'200 best packaging designs worldwide'
artpower, china
'package design 1'
'package design 2'
'package design 3'
ava publishing sa, switzerland
'basics design layout 02'
'packaging the brand'
brabants dagblad, the netherlands
cap & design, sweden
chois gallery, china
'brand & identity design'

'chois package 2'
'chois package 3'
creatie, the netherlands
credits, the netherlands
D-C-2, the netherlands
design magazine, korea
eigen huis & interieur, the netherlands
european design awards 2008, greece
european design awards 2009, greece
european design awards 2010, greece
fonk, the netherlands
futu, poland
'colour & branding'
gallery, usa
'the world's best graphics'
'the world's best packaging'
gallery magazine 16
gallery magazine 17
gallery magazine 18
gestalten, germany
'fully booked'
'boxed & labelled'
gingko press, usa
'vivid! the allure of color in design'
greytones, the netherlands
'the human freakshow'
hermann schmidt mainz, germany
'reporting'
hightone book, china
'top graphic design'
ideafried, taiwan
'the keywords on visual arts in the netherlands'
identity matters, the netherlands
idn, hongkong
'the colour issue'
index book, spain
'basic pack'
'common interest'
'green graphics'
'typoshirt one'
'around europe packaging'
'logo book'
'selected b, graphic design from europe'
items, the netherlands
kak, russia
'dutch design edition'
kek, the netherlands
lecturis, the netherlands
'dutch posters 1997-2017 by anthon beeke'
lürzer's archive, austria
lürzer's archive special, austria
'200 best packaging design worldwide'
mao mao, spain
'direct mailings'
monsa, spain
'packaging handmade'
nikkei design, japan
novum, germany
'world of graphic design'
nrc handelsblad, the netherlands
marketing tribune, the netherlands
ooogo, japan
'brand 2010'
'capture the best shopping bags'
'explore more possibilities of design'
'brand! vol.3'
pie books, japan
'business stationery'
'making the brand'
'shop image graphics'
printbuyer, the netherlands
print & finish, usa
print magazine, usa
'european design 2007'
rockport, canada
'100 principles of package design'

sandu publishers, china
'100% european graphic design portfolio'
sendpoints, hongkong
'mr packaging'
'format first vol.3'
taschen, germany
'the package design book 02'
'the package design book 03'
'the package design book 04'
'the package design book 05'
technology press, china
'best world packaging'
thames & hudson, united kingdom
'genius moves'
'icons of graphic design'
trouw, the netherlands
verpakken pagazine, the netherlands
victionary publishers, hongkong
'graphics alive'
'logology'
'save the date'
'graphics alive 02'
volkskrant, the netherlands
volkskrant magazine, the netherlands
vormberichten, the netherlands
vr magazine, the netherlands
vt wonen, the netherlands

EXHIBITIONS

the foreign affairs of dutch design, traveling 2006
dutch design database, moti, breda 2010
pentawards, paris 2012
pentawards, barcelona 2013
pentawards, tokyo 2014
national museum korea, gwangju 2015
sri lanka design festival, colombo 2015
pentawards, london 2015
lodz design festival, lodz 2016
all4pack show, paris 2016
pentawards, shanghai 2016
elephant parade, laren 2017
pentawards, barcelona 2017
pentawards, new york 2018
pentawards, london 2019

LECTURES

tokyo design week, tokyo 2014
sri lanka design festival, colombo 2015
edpa congress, taipei 2016

CREDITS

photography
raphaël bergman (us.) 82-83
michael kirkham 90-95
us. 150-151

COLOPHON

publisher bis publishers, amsterdam art direction & design studio kluif, 's-hertogenbosch intro text esther de vilder, jeroen hoedjes printer dami editorial and printing services, china studio kluif address veemarktkade 8 5222 ae 's-hertogenbosch - the netherlands telephone +31 (0)73 623 07 07 info@studiokluif.nl - www.studiokluif.com thanks team kluif for all the great work and your kluif loyalty, let's fill a new book! jeroen hoedjes, paul roeters, danny hermans, daphne koomen, marleen kuijf, rob corman, suzanne van gaal, anne van arkel, frank van beuningen, anne de bruin, edwin degenhart, ruud van den elzen, roger huskens, clemens jonas, max kortsmit, julia loder, leen van der heidt, iris van der eijken, jelena peeters, christina casnellie, heike pfisterer, frank eckl, angélique döbber, astin le clerq, anke schalk, tim schellekens, lennaert stam, jaring tolsma, sander tielen, inge villevoye special thanks to our families, ad 's-gravesande, ad de hond, alex bergman, alex jansen, aline akkerman, amy bakker, andré bongers, angelique billet, anita timmermans, anjuska slijderink, anke van der endt, anke van haarlem, ankie til, anne simons, annegien van bladel, annemarie commandeur, annemarieke piers, annet van de moosdijk, annie abbruzzese, anouk janssen, anouk robbers, anouk ten brummelhuis, antwan van bruchem, ari versluis, arjaan hamel, arjan vink, arnold van der beek, arthur dries, astrid prummel, astrid van noord, astrid van selm, barbara de lange, barbara keurntjes, barbara wolfensberger, bart frencken, bart scholten, bas kurvers, bas van gestel, bert de wildt, bettie ubels, bettina poels, bianca cameron, bianca de boer, bob in den bosch, bob sprengers, bonita van lier, boudewijn fischer, bram delmée, brenda vermaat, caatje peters, carin van sterckenburg, carla grotenberg, carline vrielink, carlos voermans, carola seubers, caroline verweij, cees rutgers, chang wong, chantal geuze, chantal gubler, charlene chedi, cindy weijnand, clarinda schipper, claudette halkes, claudia meurisch, clé enneking, clemens bolhaar, cora van dijk, daan harterink, dave boerma, david bowie, david van iersel, dennis koot, dennis slagboom, desiree hekman, dick bakker, diederik enneking, dimitri pater, dorien de voogt, dorine de wilde, dorith sleegers, duncan van der hulst, ed roeters, edward ammerlaan, eefje sperber, eeke hallo, elke smelt, ellie uyttenbroek, emelie schuttevaer, eric alink, eric brouwer, eric douma, erica haffmans, erik lugermanc, erno van den berg, ernst-jan smids, esther meegens, esther rodenburg, esther schram-de groot, esther snel, esther van veen, eva vermeulen, fabian takx, femke creemers, femke klein, fianne stroeken, florian branchet, floris hovers, francisca beth, frank hendricks, frank schippers, frank van den eijnden, frank van den horst, frank wichers, frans putters, fred kramer, fred lobregt, freddy bosscher, freek van der pol, frits kuijzer, geert olsthoorn, geert overdam, georgette van riel, gerard van eck, gerben olthof, gerry bles-rutten, gijs groenevelt, gijs stigter, govert van arkel, guus droppers, guus van hove, guy van hulst, hans haleber, hans hoedjes, hans meertens, hans van den boom, hans van driel, harold goldman, harrie henkes, harrie von wersch, harry op den kamp, herbert van sloun, herman loerakker, hessel hoekstra, hilde outmans, humphrey dindajal, huub bornheim, ilonka birsak, ilonka de ridder, ina arends, ingrid wiechers, irina flier, iris de lau, isabelle boon, isabelle savelkoul, jacco taal, jacintha overman, jack van de vijver, jacqueline van zetten, jacques koewrieden, jacques van der bom, jan geurts, jan hendrik croockewaf, jan jaap van hoeckel, jan kamphuis, jan riepko kooppmans, jane van der lest, janine rougoor, janneke brouwers, jannie vos, janny meemelink, jasper tielen, jasper van den dobbelsteen, jean jacques evrard, jeroen carels, jeroen linschoten, jeroen van de ven, jeroen van eck, jerry tracey, jimmy nelson, job conen, jody franz, joep lennarts (r.i.p.), joppe van der made, jolande bastiaans, jolien geursen, jolies van rijn, john van deursen, joke kosters, jolanda, geerts, jolanda wels, jordi bombeek, josefien van der laar, josjanne braam, josje verbeeten, joyce hageman, joyce van de ven, judith fritz, julie van severen, karel goudsblom, karin sakkers, karin witteveen, katja berest, kees de vos, ken sofer, kickan schipper, kiki hehemann, kim de koning, klaartje wouters, laura moreira, laurent koelink, leo kind, leon van den broek, leontine hagoort, lex kiffen, liam maher, lian duif, lieke van den boogaard, lies frankhuyzen, liesbeth hoedjes, lilian wagenaar, lissa kooijman, liza hollingsworth, lode schaeffer, lotte landsheer, louise bosch, maaike hoekstra, maaike lups, maarten baas, maarten valk, maartje kuiper, maartje mulckhuijse, machteld van zalingen, malou franssen, manon van de wiel, manuela van den berg, marc eysink smeets, marc koppen, marc versteeg, marc vlemmix, marc vleugels, marc wiggers, marcel wolff, marco huisman, marco timmermans, margje van hooijdonk, margo gommers, margo lansink, margot vos, marie-josé ter laan, marieke heuvelman, marieke mooijen, marieke olsthoorn, marieke thomassen, marieke van inssen, marieke van zuiphen, mariel reuvers, marije vogelzang, marijn olislagers, marina witkamp, marion homburg, marion verschuijten, mariska kloezen, mariska reijmers, mariska verhulst, marja bernts, marjan versteeg, marjolein hodes, mark bogaerts, mark geersaem, mark de jonge, marleen stuart, marlies timmermans, martijn kicken, martine ansems, maureen kemeling, mechtild stultiens, melanie rudolf, menno van der vlist, meta opdam, mia goes, michel de boer, michel min, michiel kalkman, mieke van deursen, miesjel van gerwen, milou ket, miranda de jong, miranda derks, miranda klaver, miranda valk, miriam kooger, mirjam emmen, moniek (ugly) in den bosch, monique ariesen, monique hemelaar, monique van der vlist, monique wigman, nathalie gadeyne, nicole opreij, nicolette obers, niels korthals altes, niels wouters, nienke beerens, nieta van arkel, niki smit, noes butter, pao liene djie, patricia beks, patrick wauters, paul du crocq, paul schouten, paul van der eerden, peter tabernal, peter van soolingen, petra van velzen, piet van de laak, pieter tielen, pim van arkel, pim welvaarts, poeki cuppens, ralph bloemen waanders, raymond goes, renate van iperen, rené bergmans, rené repko, rené van der hulst, richard mooij, rick vermeulen, rob bonnemaijers, rob rutjes, rob stahl, rob van de ven, robert bohemen, robart jan blekemolen, robin blitzblum, roco braas, roderick verplanken, roel mos, roel venderbosch, rogier roeters, ronald dudok, ronald kuiper, romeo sommers, ruben wegman, rudo hartman, rudolf van wezel, rudy daverveld, ruud pijnenburg, ruud van der donk, ruud van wingerden, saïda bou-chamach, sake smid, samantha williams, sander honig, sander uyleman, sander van vlerken, sandra kuster, sandra van lieshout, saskia wagemakers, seeke blokland, serge steijn, siebrand weesjes, silvia van der kallen, simone kramer, simone porteder, simone roeters, simone tordoir, sonja blok, stefan la haye, stella van velden, stephanie pander, steven aaldriks, steven de cleen, stijn groenink, susan kock, susanne van bilsen, suzanne bruijstens, suzanne de rooij, suzanne lustig, suzanne van amstel, suzanne van beek, suzanne weerkamp, swantje hinrichsen, sylvia stølan, sylvie verbiest, ted grönsen, tessa harmsen, thierry quinten, thijs hagenberg, thijs janssen, tilly hazenberg, tineke meirink, toine ooms, ton van eijk, ton westendorp, toon branbergen, toon michiels, trudy dorrepaal, tycho merijn, vera veldman, victor paashuis, vincent blokland, viviana daniels, walter huijboom, wendy bouwmeester, wieke van der aa (r.i.p.), wietske claessen, wietske doreleijers, wilfred jacobs, wilko thijssen, will van sambeek, willem badenhop, willem kars, willem marcelissen, willem melsen, willem olsthoorn, willy smits, wilma veldman, wim euverman, yolanda bakker, ziggy, zya erteling and all other friends we may have forgotten.